KinoSputnik

RUSSIAN ARK

Aleksandr Sokurov

Birgit Beumers

intellect Bristol, UK / Chicago, USA

First published in the UK in 2016 by
Intellect, The Mill, Parnall Road, Fishponds, Bristol, BS16 3JG, UK

First published in the USA in 2016 by
Intellect, The University of Chicago Press, 1427 E. 60th Street,
Chicago, IL 60637, USA

A catalogue record for this book is available from the British Library.

Copy-editor: Michael Eckhardt
Cover designer: Emily Dann
Production manager: Matthew Floyd
Typesetting: Contentra Technologies

ISBN: 978-1-78320-703-9
ePDF: 978-1-78320-704-6
ePUB: 978-1-78320-705-3

KinoSputnik

RUSSIAN ARK

CONTENTS

Note on transliteration

The Library of Congress system has been used throughout, with the following exceptions: when a Russian name has an accepted English spelling (e.g. Tchaikovsky instead of Chaikovskii; Chaliapin instead of Shaliapin), or when Russian names are of Germanic origin (e.g. Eisenstein instead of Eizenshtein; Schnittke instead of Shnitke). I have also used the accepted spelling for Mariinsky (instead of Mariinskii) Theatre, and for the names of tsars or emperors (e.g. Nicholas instead of Nikolai; Alexander instead of Aleksandr). Where a source is quoted, the original spelling has been preserved.

Acknowledgements

I would like to thank May Yao, Jessica Mitchell and Matthew Floyd at Intellect Books for their enterprise in launching this new series of KinoSputnik, and I am hugely indebted to Richard Taylor, Denise Youngblood and Julian Graffy for their trust and support. My special thanks go to Nathalie Muller at Idéale Audience for allowing me to view *Francofonia*, and to Natal'ia Chertova in Moscow for her kindness and inspiration.

KinoSputniks general editors' preface

This series intends to examine closely some key films to have emerged from the history of Russian and Soviet cinema. Continuing from *KinoFiles* (2000–2010), the *KinoSputniks* are intended for film enthusiasts and students alike, combining scholarship with a style of writing that is accessible to a broad readership. Each *KinoSputnik* is written by a specialist in the field of Russian and/or film studies, and examines the production, context and reception of the film, whilst defining the film's place in its national context and in the history of world cinema.

Birgit Beumers & Richard Taylor
Wales, June 2016

List of illustrations

Production credits

Russian title:	*Russkii kovcheg*
Producers:	Andrei Deriabin, Jens Meurer and Karsten Stöter
Production companies:	Hermitage Bridge Studio [Ermitazhnyi Most] (St Petersburg) and Egoli Tossell Film AG (Berlin). Co-produced by NHK, Seville Pictures Inc., Kopp Media, WDR/arte, Fora Film, M and AST Studio. With the participation of The State Hermitage Museum; Ministry of Culture of the Russian Federation, Department of State Support for Cinematography; Mitteldeutsche Medienförderung; Filmboard Berlin-Brandenburg; Filmförderung Hamburg; Filmbüro Nordrhein-Westfalen; Kulturelle Filmförderung des Bundes; Kulturelle Filmförderung Sachsen-Anhalt; YLE/TV1; DR1; Seville Pictures Inc.; Studio Babelsberg; and Das Werk (Stephen Coppen).
Release date:	2002 (UK: 4 April 2003)
Director:	Aleksandr Sokurov
Screenplay:	Aleksandr Sokurov, Anatolii Nikoforov; dialogue: Boris Khaimskii, Aleksandr Sokurov and Svetlana Proskurina
UK distributor:	Artificial Eye
Director of photography:	Tilman Büttner
Sound mix:	Dolby SR
Aspect ratio:	1:1.85
Production design:	Elena Zhukova and Natal'ia Kochergina
Lighting:	Anatolii Rodionov and Bernd Fischer
Casting:	Tat'iana Komarova
Costume design:	Lidiia Kriukova, Tamara Seferian and Mariia Grishanova
Make-up:	Liudmila Kozinets and Zhanna Rodionova
Original music:	Performed by State Hermitage Orchestra
Music:	Mikhail Glinka (*Life for a Tsar*), performed by the Mariinsky Theatre Orchestra and conducted by Valerii Gergiev
Composer:	Sergei Evtushenko, with arrangements from Glinka, Tchaikovsky, Purcell and Telemann
Editing and Digital Imaging:	Sergei Ivanov
Sound:	Vladimir Persov and Sergei Moshkov

| **Choreographer:** | Galy Abaidulov |
| **Running time:** | 96 minutes |

CAST

Stranger/Custine	Sergei Dreiden
Catherine the Great	Mariia Kuznetsova
Spy	Leonid Mozgovoi
Mikhail Piotrovskii	Himself
Prince Orbeli	David Giorgobiani
Boris Piotrovskii	Aleksandr Chaban
Lev Eliseev	Himself
Oleg Khmel'nitskii	Himself
Alla Osipenko	Herself
Talented Boy	Artem Strel'nikov
Tamara Kurenkova	Herself
Peter the Great	Maksim Sergeev
Catherine the First	Natal'ia Nikulenko
First Lady	Elena Rufanova
Second Lady	Elena Spiridonova
Nicholas I	Iulian Makarov [real name: Iurii Zhurin]
Nicholas I's wife	Svetlana Svirko
First Cavalier	Konstantin Anisimov
Second Cavalier	Aleksei Barabash
Third Cavalier	Il'ia Shakunov
Alexandra Fedorovna (Nicholas II's wife)	Anna Aleksakhina
Nicholas II	Vladimir Baranov
Chancellor Nesselrode	Boris Smolkin
Master of Ceremonies	Kirill Dateshidze
Chamberlain	Vadim Lobanov
Persian Envoy	Suren Vartanov
Narrator	Aleksandr Sokurov

SCREENINGS AT INTERNATIONAL FESTIVALS (AND AWARDS)

Cannes Film Festival, 2002
Karlovy Vary International Film Festival, 2002
Chicago International Film Festival, 2002
London International Film Festival, 2002
Pusan International Film Festival, 2002
Toronto International Film Festival, 2002 (Visions Award)
Sitges – Catalonian International Film Festival, 2002
San Francisco Film Critics Circle, 2003 (Critics' Prize)

Málaga International Week of Fantastic Cinema, 2003 (Best Actor – Dreiden; Best Cinematography – Büttner; Best Director – Sokurov)

European Film Academy (EFA), 2002 (Nomination for Best Director and Best Cinematography)

NIKA Awards, 2003 (Best Production Design and Best Costume Design; nominations for Best Film and Best Sound)

German Camera Award, 2003 (Honourable Mention for Tilman Büttner)

Argentinian Film Critics Association Awards, 2004 (Silver Condor – Best Foreign Film)

Plot summary

An invisible man, disorientated and suffering from memory loss, and who speaks with Aleksandr Sokurov's voice, finds himself outside the Hermitage some time in the nineteenth century. Inside the building, he meets a Stranger, modelled on the French diplomat Marquis Astolphe de Custine, who is also unsure about the time and place. Together, the visible Stranger and the invisible Narrator embark on a long walk through the space: a museum of art and an imperial residence.

Exploring the palace, the Marquis and Narrator engage in a conversation about Russia and the influence that European culture exerted on the country. They enter the Hermitage through a basement section, where they see Peter the Great beating one of his generals. They continue, emerging in the Hermitage Theatre, where an orchestra plays music for a dramatic performance watched by Empress Catherine the Great. The Marquis wanders through the rooms of the Hermitage, starting with the Raphael Loggias and continuing through the Small Italian Skylight Room, the Van Dyck and Rubens Rooms, the Room of Netherlands Art, the Tent Hall (also known as Tent-Roofed Room, or Room of Dutch Paintings) and the Rembrandt Room before being ushered out of the museum's art collection into the Pavilion Hall, where he meets an elderly Catherine the Great in conversation with a group of children. Throughout this part of the journey, Custine is introduced by the Narrator to contemporary visitors of the museum: a doctor and an artist, a young boy, a blind woman, a dancer, and two sailors. Custine's conversations with them reveal his arrogant attitude and negative views on Russia and her culture.

As they continue their journey through St George Hall, the Armorial Hall, the Concert Hall and Great Nicholas Hall, Custine passes through key episodes of Russian history, from Nicholas I's reception of the Persian envoy following the murder of Russian diplomats in Tehran (1829), to three generations of the Hermitage Museum's directors in conversation, to the children of Alexandra and Nicholas II joining their parents and the sickly tsarevich Alexei at the dinner table. From there, the visitors move to the last great ball held in the Winter Palace in 1913. Having danced a *mazurka* to the music played by the Mariinsky Theatre's orchestra and conducted by Valerii Gergiev, Custine exits with all the guests of the ball, descending the Main or Jordan Staircase. The Narrator leaves him there and turns to the exit, where the eye of the camera captures the murky grey of the River Neva.

Chapter 1
Introduction and production history

– Here, shooting in a single take is an achievement in formal terms, but more than that it is a tool with the aid of which a specific artistic task can be resolved. It's just a tool.

– What is this tool called?

– Breathing. One has to live a specific amount of time in a single breath […]. This idea was for a film shot, as it were, 'in a single breath'.

(Sokurov in 'Press Release' 2002: 5)

Most writing on *Russian Ark* begins or ends with a comment on the technical feat achieved with this film. Let me therefore also begin here with some technical aspects. Above all, we must remind ourselves of the context: although digital technologies were available in 2000–01, when Aleksandr Sokurov embarked on this project, they were not widespread. Cell phones had just about saturated 20 per cent of the world population, some half of the population owned a computer, and the DVD (first retailed in 1997) had just learnt to spin. Digital cameras had entered retail in the mid-1990s. To achieve the feat of recording 90 minutes of footage in one take, digital technology was, however, the only option, because standard reels of 35mm film come in at 305 metres and only run for about twelve minutes. Whilst the documentary and feature film-maker Sokurov was dreaming of this 'single-breath shot', technologies continued to develop. But even in 2000, recording digital footage onto a platform in a single shot was impossible. Uncompressed recording on HD takes up a lot of space on a hard drive, and in 2000 the world was still counting in megabytes rather than gigabytes, never mind terabytes.

Through his work with German producers, Sokurov had contacts in Berlin, where the company Kopp Media is based; they were HD specialists and had developed a hard-disk recording system for a Compact 24p High Definition camera (Sony HDW-F900) with the visual quality and portability sufficient to make a feature film. Such an HD camera (the system that Sony calls CineAlta) could record 46 minutes onto a single tape. However, a company called Director's Friend in Cologne then developed a hard-disk recording system that was portable and had a stable battery, so that it could record 100 minutes of uncompressed image in one take ('Press Release' 2002: 10). And that was what Sokurov needed.

Sokurov now needed a cameraman who had experience with a Steadicam. Sokurov had tended to work with the same cameramen – Sergei Iurizditskii and Aleksandr Burov – and even take the camera himself in such films as *Telets/Taurus* (2000) and *Solntse/The Sun* (2005). Yet he needed the expertise of the best man with the Steadicam, Tilman Büttner, who had proven himself on such films as *Lola rennt/Run Lola Run* (Tykwer, 1997) and *Absolute Giganten/Gigantic* (Schipper, 1998).

Büttner embarked on the project with a great deal of technical expertise, but little knowledge of the historical background or Sokurov's filmography (as is evident from his interview in 'Proekt' in 2002). He ordered a special Steadicam armature in Canada (the model 'Tilman Büttner #1') that could be mounted on a strap so that the weight of the device could be placed on the hips. The camera weighed nine kilograms, while the overall weight carried by the cameraman, including the hard disk, came to about 35 kilos.

In this way, it had become technically possible to record 90 minutes of uninterrupted footage onto a digital system: 'the first entirely unedited, single screen, single take full-length feature film; the longest-ever Steadicam sequence, the first ever uncompressed HD movie, recorded onto a portable hard-disk system, rather than 35mm or tape' ('Press Release' 2002: 9).

But these technical feats alone were not enough. Sokurov's film was shot in the Hermitage Museum, home to one of the richest and most precious art collections in the world. Any film crew allowed inside has to operate to a high level of care for the objects and numerous restrictions applied. Sokurov's good and established relationship with the Hermitage's director, Mikhail Piotrovskii, certainly helped. Sokurov had previously shot several educational films in the Hermitage and also premiered his films in the Hermitage Theatre (converted for this purpose to a cinema). His film *Rober. Schastlivaia zhizn'/Hubert Robert: A Fortunate Life* (1996), produced by Hermitage Bridge Studio with Andrei Deriabin, is a fine example of Sokurov's interest in the filming of artworks on the one hand, and his collaboration with the museum on the other.

Moreover, Sokurov mounted an additional challenge for himself: filming in the Hermitage meant that the museum would have to close for the day of the shooting. He chose the shortest day of the year – 23 December – for the shoot, when daylight during the black polar nights of St Petersburg was available only for a few hours (the southern solstice fell on 21 December in 2001). Thus the film crew had a limited amount of time for rehearsals on location; needed a good supply of lighting; had to find a way of getting actors, crew and extras into the Hermitage; had to restore some of the historical rooms to their original state (including removing paintings); and had a few other feats to accomplish.

The crew had to track a path for the camera totalling 1500 metres in length, through 36 halls, rooms and galleries (some sources say 33, which excludes some rooms where characters merely pass through) containing 200 lighting devices. The 65 costume assistants from Lenfil'm, the Mariinsky Theatre and other theatres in the city had to dress the 862 actors and extras (101 solo, 280 in groups, 481 in crowd scenes) in a total of 360 costumes, including 45 ball-gowns and 120 uniforms.[1] Meanwhile, three make-up supervisors and their 50 assistants from the film studio, theatres and television had to disperse three buckets of powder and arrange 100 wigs (made from five kilograms of natural and six kilograms of artificial hair), whilst 22 assistant directors co-ordinated the movement of the crowds and actors. Three orchestras were involved in the shoot, including that of the Mariinsky, conducted by the maestro Valerii Gergiev, who flew in from a concert in New York the night before the filming.

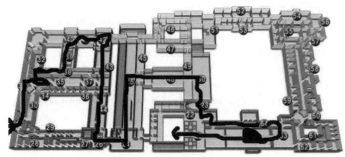

Figure 1: The path of Custine and the camera.

CHRONICLE OF A FILM

15 April 2001 – Casting begins

22–23 April – Technical test with Tilman Büttner in the Hermitage

19 June – Sokurov meets with Gergiev, who agrees to conduct the *mazurka* with the Mariinsky Orchestra

September – Meeting with Aleksandr Golutva (Deputy Minister of Culture)

5 October – Meeting with producer Andrei Deriabin and St Petersburg's governor, Vladimir Iakovlev, to include the project into events for the 300th anniversary of the city in 2003

5 November – Second rehearsal with Büttner, including actors; plan for lighting

20 October – Rehearsals begin between Lenfil'm and Hermitage (closed on Mondays)

18 November – Daily rehearsals start with four assistant directors: Sergei Razhuk (ball, Persian envoys with the tsar, and scenes on staircases); El'vira Krupina (Peter I, Nicholas II); Tat'iana Komarova (Catherine and children in Pavilion Hall); Aleksandr Maslov (Hermitage Theatre and Siege)

15 November – St Petersburg's vice-governor arranges special access for the film crew to the Hermitage, and orders the closure of Palace Square for 23 December

24 November – Equipment arranged and tested

30 November – Crew meeting

5 December – Meeting of Sokurov and Gergiev

6 December – Arrival of the German team, including producer Karsten Stöter

10 December – Rehearsal in the Hermitage, including Mikhail Piotrovskii

13 December – Film crew arrive at the Hermitage

22 December

7.00 Set up the decors along the entire track of the shooting. Bring in costumes

8.00–12.00 Film crew (30 people) and actors (seven people) enter for rehearsal inside the Hermitage. Dismantling of paintings in the Portrait Gallery of the Romanovs

12.00–21.00 Set-up of lighting and other equipment along the track

21.00–22.00 Costume assistants and make-up assistants (50 people) enter into the Hermitage

22.00–1.00 Actors enter for crowd scenes (770 people)

23 December

1.00 – Technical crew enter

1.00–2.00 Make-up and dressing for crowd scenes; preparation for rehearsal

2.00–3.00 Rehearsal on the Jordan Staircase

3.00–5.00 Rehearsal in St George Hall (300 people)

5.00–6.00 Rehearsal in Nicholas Hall

6.00–9.00 Coffee break for crowd scenes and film crew

9.00–10.00 Crowd scene actors move into halls

10.00–11.30 Movement of film crew and actors along the shooting track

12.00–14.00 SHOOT

14.00–15.30 Admission of journalists through Saltykov entrance (60 people) and press conference in the Hermitage Theatre

14.00–21.00 Removal of equipment

31 December – Start of post-production

10 January–3 February 2002 – Sound recordings

(adapted from 'Proekt' 2002)

As Svetlana Proskurina (in Sirivlia 2002) records, different layers of sound (noise, voices, music) were added in the post-production process, as (following widespread practice in Russian cinema) no original sound was recorded during the single take on 23 December. The images were mastered in post-production, mostly adding colour filters to tint certain scenes.

There is not a single cut in the original film. Yet when it reached distribution, *Russian Ark* was largely screened from 35mm prints, which means that the projectionist would splice the separate reels together and mount the entire feature onto a platter. In 2003, cinemas were not yet equipped with the technology for digital projection, which was emerging at the time. Bristol's Watershed – part of the Europa Cinemas network – was one of the few venues capable of digital projection,[2] and screened the film every weekend over three months from April to June 2003, with special introductions for each screening. Having first screened the film from 35mm, Watershed struck a deal with the UK distributor, Artificial Eye, for the Digibeta tape to be projected from a Digital Projection Highlite 5000gv projector with a Texas Instruments chip (Minns 2003), making it one of the few cinemas to show the film digitally.

As such, the technical feat – the take in one breath – that so many reviewers had commented upon was fragmented during the projection. The aim for perfection during the shooting – with the crowd management and the flubs only partly corrected in post-production, as Jose Alaniz has demonstrated (Alaniz 2011) – leaves us wondering about the purpose of this high-tech exercise. Sokurov had outdone Russian auteur Andrei Tarkovsky in the length of shot; he had opposed Dziga Vertov's and Sergei Eisenstein's montage technique (even if only on a technical level), because his distortion of historical space and time is just as manipulative as that of the great masters in *Bronenosets Potemkin/ The Battleship Potemkin* (Eisenstein, 1925) or *Oktiabr'/October* (Eisenstein, 1927); and he had achieved what Alfred Hitchcock in *Rope* (1948) could only pretend to do, namely that the camera never left the shooting location.

This ambitious project was conceived by a film-maker with a huge body of work already attached to his name, with an international reputation (festivals at Berlin, Cannes, Karlovy Vary) and a track record of international co-productions. It was produced by Andrei Deriabin, the St Petersburg-based head of Hermitage Bridge Studio, a subdivision of the Hermitage that focused on work with the museum; by Jens Meurer of Egoli Tossell, who had wide-ranging experience in Russia and on documentary films; and by Karsten Stöter, who had previously worked with Meurer. Sokurov's German connection also included the highly influential producer Thomas Kufus, who had produced *Molokh/Moloch* (1999) and *Otets i syn/Father and Son* (2003).

Sokurov's background is in history, and this is well reflected not only in his early documentary films – including films about artistic figures such as Dmitrii Shostakovich, Fedor Chaliapin, Andrei Tarkovsky, Mstislav Rostropovich and Galina Vishnevskaia, and political figures such as Boris Yeltsin[3] – but also in his fiction films, especially the trilogy about the dictators Hitler (*Moloch*), Lenin (*Taurus*) and Hirohito (*The Sun*). Yet Sokurov is never interested in

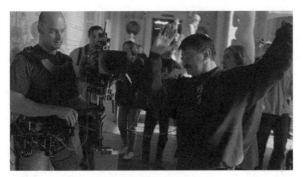

Figure 2: Tilman Büttner and
Aleksandr Sokurov on the shoot.

presenting historical facts, but in the personal behind the historical, political or artistic figure. This is an important aspect of his choice of historical and contemporary figures to populate the Hermitage in *Russian Ark*, which is ultimately subjective.

His interest in art has manifested itself in his film style, as is evident from the slow-moving camera, which often captures scenes in complete stillness. This can be seen in the opening sequence of *Mat' i syn/Mother and Son* (1997), which opens with a still scene that appears to be painted, but gradually becomes animated as the characters begin to breathe and move. Moreover, Sokurov makes extensive use of anamorphous lenses to distort the image (Alaniz 2008), giving it a panoramic vision and a painterly quality. However, Sokurov is not only preoccupied with the painterly quality of his cinematic shots, but also displays a keen interest in the still, frozen and immobile nature of still life, as reflected in his frequent citation of, or inspiration by, painterly compositions. Especially important here is that the composition of paintings highlights the morbidity of the present, something Sokurov observed in Hubert Robert's ruin paintings, which almost seem to come to life through his camera in the documentary *Hubert Robert* (1996), as well as in *Elegiia dorogi/Elegy of a Voyage* (2001), about the Boijmans van Beuningen Museum in Rotterdam. For Sokurov, the medium of cinema is inferior to the medium of art; as such, the choice of museum and artworks, paintings and sculptures for *Russian Ark* is not accidental. As Sokurov has said: 'The art of cinema does not exist. Cinema is secondary' (Grashchenkova 1997: 82); 'If film as art exists, then the real problem resides in optics' (Sokurov in Sedofsky 2001).

Therefore, the second chapter, on contexts, pursues several different lines. First, I discuss the role of the Marquis de Custine as a guide through the Hermitage and commentator on Russia's history and culture; his views on the relationship between Russia and Europe are informed by the important debate between Slavophiles and Westernizers that erupted precisely around the time of his visit to Russia in 1839. Second, I explore the role of the location: the ark that contains Russia's history and culture is a building that has two functions, and indeed two designations: the Winter Palace as the site of the tsars' residence, reflecting the history of imperial life; and the Hermitage as the building that contains the art collection and is one of the largest museums in the world.

The third chapter, offering a close reading of the film, follows the camera in *Russian Ark* in a scene-by-scene, or rather room-by-room, analysis. The fourth chapter explores the film's main themes and motifs, building on the binaries and duplicities inherent in the film's construction. The final chapter covers the reception of *Russian Ark* in the press and the debates it initiated in scholarship. In the conclusion, I return to the issue of Sokurov's relationship to visual art, and take a look at the relationship to cultural heritage that Sokurov offers in *Francofonia* (2015), a film about another museum: the Louvre.

Chapter 2
Contexts

THE MARQUIS DE CUSTINE

'Russia has no past […] but the future and space may serve as a pasture for the most ardent imaginings.'
Astolphe Marquis de Custine, 22 July 1839.

(Buss 1991: 97)

The journey through the Winter Palace and the Hermitage is a journey through time and space, who visited Russia in 1839 and who is performed by the invisible Narrator, who speaks with Sokurov's voice, and the Stranger, Astolphe Marquis de Custine (played by Sergei Dreiden [Dontsov]). History unfolds chronologically, starting with Peter the Great and ending with Nicholas II, and yet Custine's status in this chronology shifts. In the state apartments, he passes almost unnoticed; meanwhile, in the rooms with the collections of European art, populated by contemporary visitors and people from different centuries, he is visible and converses with the crowd; later on, he is ushered out of the museum.

At the film's start, he talks of being lost, not knowing where he is and not recognizing the location. He is surprised that he speaks fluent Russian. His temporal dislocation is enhanced by his dress – he wears a black, nineteenth-century suit – very much like the Custine who donned 'as much of a court costume as he could assemble from his travel wardrobe' (Kennan 1972: 56) for his first visit to the Winter Palace, where he attended the wedding and subsequent ball of the tsar's eldest daughter, Grand Duchess Maria Nikolaevna, to Maximilian de Beauharnais, Third Duke of Leuchtenberg, on 14 July 1839 (Buss 1991: 60). Custine's ship had docked in Kronstadt on 10 July 1839, and his attendance at the wedding comes before his formal introduction to the court. On the day, he feels terribly out of place, especially when his shoe is caught in a carriage door and drags along the steps leading up to the Hermitage, to a ball where he knows nobody (Kennan 1972: 57).

The historical Custine visited the Hermitage in 1839, after the fire of 1837 which had destroyed large sections of the building. However, in *Russian Ark* he moves essentially through rooms designed by Leo von Klenze (1784–1864) in 1851, commissioned by Nicholas I to house the New Hermitage, which would contain the Romanovs' art collection. At the time of Custine's visit, only the imperial apartments of the building had been restored by Vasilii Stasov, largely drawing on the original designs of the French neoclassical architect Auguste de Montferrand (1786–1858), who had created the Alexander Column and St Isaac's Cathedral, and the plans of Giacomo Quarenghi (1744–1817), responsible for the designs of the most significant buildings in Moscow and St Petersburg under Catherine II and Alexander I, including the Hermitage Theatre and the Raphael Loggias. While the spaces filled by historical figures were actually visited by Custine, his visit to the Hermitage's art collection takes him to a virtual space, to rooms that he could not have visited in 1839. Sokurov grants Custine a view into the 'ark', into the space of a collection that

he was unable to see in its full glory in 1839. Therefore, Custine's comments on these paintings are crucial for an understanding of the assessment that Sokurov gives to his main character, whose historical and political observations we know full well from his memoirs. Custine gazes at a number of pictures that were not in the Hermitage in 1839. However, he does not differentiate in his commentary on paintings by way of indicating whether he is seeing a painting for the first time on his present tour, or whether he has seen a work before.

Astolphe, Marquis de Custine (1790–1857), was a French aristocrat who visited Russia in an attempt to find there a justification for absolute monarchy; he came back a convinced republican: 'he went to Russia an admirer of autocracy and returned a supporter of a representative government' (Buss 1991: xvi). The choice of Custine as a guide deserves a short excursion into the Marquis' life. Custine was born into a French aristocratic family in 1790, but his father and grandfather fell victim to the terror after the Revolution and were guillotined in 1792. His mother, Delphine, overwhelmed her only child with love (Astolphe's elder brother Gaston, born 1788, had died in 1792), and it was through her protection that he was assigned posts as a military commissioner and later as aide to the diplomat Talleyrand during the Congress of Vienna in 1814–15, where a peace plan for Europe was drawn up after the defeat of Napoleon. Delphine also arranged a marriage for him, hushing up his homosexual orientation, which was exposed in a scandal in 1824, when Custine was attacked during a rendezvous with a young guardsman (Kennan 1972: 5–7; Buss 1991: x–xi). Custine was forced to withdraw from his social life in Paris, and reoriented his career as a diplomat toward travelling and writing.

Having been introduced early on in his life to the literary circles at his mother's house – which included her lover Chateaubriand and her friend Madame de Staël – and after several personal tragedies (including the death, aged only 21, of his wife Léontine de Saint-Simon de Courtomer, for whom he cared during a prolonged illness), Custine finally, and after several attempts at poetry and at writing a play, gained recognition for his travel account of a journey to Spain in 1838 (*L'Espagne sous Ferdinand VII*). His success, following that of the publication of Alexis de Tocqueville's *Democracy in America* (1835), led him to venture on a trip to Russia, a country that, like Spain, only partly adhered to European traditions, while offering a possible 'cure' from French republicanism. Custine's choice of Russia has also been put down to a desire to plead for Count Ignace Gurowski, who had fled to France during the Polish struggle for independence, to be allowed to return. More important, though, is Custine's wish to gain some insights into the other extreme of social organization from Tocqueville's report on America. Russia was an autocracy and Custine intended to use it as negative case study. Custine thus went to Russia not only armed with a whole range of history books and well-read about the country's history and culture, but also with a set of preconceived ideas that he sought to confirm. However, his first-hand view of the country would change some of those perceptions while confirming others. He sought justification for his vehement opposition to representative government, where the borderline between autocracy and democracy was merely blurred, and which Custine saw as a form of social organization that ultimately led to chaos and disorder:

> For Custine, democracy meant mob rule and the dictatorship of public opinion, through rabble-rousing speeches and the press [...]. He did not favour absolutism in itself, and if he was drawn towards the notion of an enlightened despot, the key word was 'enlightened'.
>
> (Buss 1991: xiii)

However, upon his return, he favoured precisely such a representative government, having observed an 'enlightened autocrat' in the figure of Nicholas I, having seen the consequences of this form of government for the people and assessed the long-term impact of such a social order on Europe: 'since I have been in Russia, I have taken a dark view of the future of Europe' (Buss 1991: 134).

Custine's account of his visit to Russia, published in 1843 in four volumes under the title *La Russie en 1839/ Russia in 1839*, brought him success as a writer, while his harsh and cynical account of Russian despotism was

banned in Russia. It would later feed conveniently into the Cold War narrative of a Russia that would eternally stand alone, incapable of integrating itself into the West or contributing to Europe (cf. Kachurin and Zitser 2006). Indeed, the Cold War historian George F. Kennan, who developed the policy of 'containment' of the Soviet Union, would publish a book about Custine and Russia (1972).

Custine's account takes the form of letters, which he appears to send from his journey to and through Russia to an unspecified recipient. Yet this is a guise, for Custine not only had all his books confiscated upon arrival in Russia (as he himself writes) – meaning he would not have been able to quote from ambassador Haberstein's correspondence or from the historian Nikolai Karamzin, as he does (Buss 1991: 40–41) – but neither did he send or bring any letters out of Russia, having been subjected to further controls and checks on his return journey via Tilsit in October 1839. The epistolary form is thus a façade for his impressions, which are also inaccurate and obscure as far as some names and details are concerned. Thus, for example, it is not clear from Custine's account whether he did meet the philosopher Petr Chaadaev or not, nor whether he visited Prince Odoevskii and Prince Viazemskii, to whom Custine had been recommended by the historian Aleksandr Turgenev, whom in turn he had visited en route in Germany (Kennan 1972: 60–61). 'Custine is not a faithful analyst of the Russia that he saw, but a remarkable prophet of the Soviet Union to come' (Buss 1991: xxi). Indeed, what worries and angers Custine is less the autocracy than the readiness of the people to subordinate themselves, to surrender and be subdued by it; this also explains his aggressive and condescending attitude when his film character converses with the visitors in the Hermitage. Most importantly, it is the reason for the book being banned in imperial Russia at the time of its publication, and later in Soviet Russia, when Stalin's regime turned out to be a continuation of tsarist autocracy (Buss 1991: xxi). Curiously, and anachronistically, Custine is asked to sign a copy of the book in a scene in the film.

Custine finds Russia a terrifying police state, a country where people lie bluntly to the foreign visitor, and build a façade of splendour and entertainment to hide chaos; where the ruling despot is adored by his slaves, who live in their misery only to be rewarded with salvation in death; where neither the church has any moral authority, nor the nobility any duties. Russia is a country that lacks a national identity, imitating Europe instead:

> I do not blame the Russians for being what they are; I blame them for pretending to be what we are. They are still uneducated – this condition, at least, leaves the field open for hope. But I see them endlessly possessed with a mania for imitating other nations, and they imitate them in the manner of monkeys, making what they copy ridiculous. [...] Wavering for four centuries between Europe and Asia, Russia has not yet succeeded through its own efforts in making its mark in the history of the human spirit because its national character has been effaced by borrowings.
>
> (Kohler 1980: 69, 229)

The use of Custine as a guide through Russian history is an ambivalent gesture on the part of the film-maker. He is, above all, a character out of time and space. Custine actually confuses the Hermitage with Chambord at one point, and the film never refers to the year of his actual visit, 1839. He is almost ghostlike, remaining invisible to some and being chased away by others. Custine's comments are aggressive and cynical. He has no esteem for Russian culture or history, as is clear from his *Russia in 1839*, yet he enjoys the splendour.

Sokurov seems to have taken several clues from Custine's biography and letters: the despondency with the nation's passivity, as outlined above; and the repeated accusations of imitation, role play and mechanical, unthinking execution of actions. With this goes Custine's admiration for the splendour, coupled with a rejection of the imitative nature of Russia's culture. Here, Custine shows an almost ambiguous assessment of Russia: there is 'Custine the solitary observer, and Custine the well-connected Marquis' (Buss 1991: xv), a feature noted by Robin Buss (1991) in his introduction to the *Letters from Russia* (a selection of letters chosen by Pierre Nora in 1975 for a single-volume edition for Gallimard, republished with a new introduction by Catherine Merridale in 2014). This may suggest the

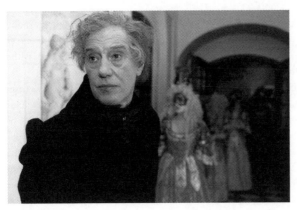

Figure 3: The Marquis de Custine
(Sergei Dreiden).

split of the meek and isolated voice with which the Narrator speaks, stopping Custine, halting his progress and thus making him fear. Apart from this ambiguous relationship to the splendour and debasement, the civilisation and barbarity, the discipline, thoughtlessness and lack of responsibility, there is another binary that Sokurov picks up from Custine, and this is both a narrative and historical one: the role of Russia between Europe and Asia, between civilisation and barbarism: 'the Russian Empire is a country where the people are the most unhappy – because they suffer, simultaneously, the disadvantages of barbarism and the disadvantages of civilization' (Custine 1980: 234). Custine is despondent about the passivity of the people and their readiness to sacrifice their lives for the tsar, whom they call their 'Father': 'An oppressed people always deserves its suffering; tyranny is the handiwork of nations, not the masterpiece of a single man' (Buss 1991: 59). Custine here echoes the arguments made in the debate which arose around the time of Custine's visit between Westernizers, who believed that Russia depended on Europe to make progress, and the more conservative Slavophiles, who saw Russia's path in autocracy and a strict observance of orthodox rituals, turning away from European influences. Petr Chaadaev's *Philosophical Letters* (written 1828–31, the first letter published in 1836) instigated this debate by positioning Europe as an ideal, with the charge that Russia was lagging behind; Chaadaev was subsequently declared insane. Chaadaev's comment on a vigilant Russia that 'cannot take its eyes from the West' (Kujundzic 2003) has a double resonance, both in Custine's perception of Russia and in the narrator's optics as his camera relentlessly follows the visitor. The Slavophiles, on the other hand, led by the literary critic and philosopher Ivan Kireevskii (1806–1856) and the theologian Aleksei Khomiakov (1804–1860), rejected the Westernization project of Peter the Great and Catherine the Great in favour of old Slavic rituals and forms, and called for the purity of the Russian language. This debate would inform much of Russia's attempts at self-definition and the formation of a national identity in the nineteenth century, and it forms an important backdrop for the discussion between the Narrator and Custine about Russia's relationship with Europe.

During his walk through the museum and Russia's past, Custine is engaged in a conversation with an invisible character reminiscent of the men Custine suspected of following him during his 1839 visit: 'They refuse you nothing, but they accompany you everywhere: courtesy becomes a means of surveillance here' (Kohler 1980: 138). The Narrator himself is lost, though; he is not sure what has happened. Some catastrophe has eclipsed the past, making him uncertain about his own identity and role, and suspecting that the spectacle he is about to witness has been staged *for* him, rather than his being expected to take part in the performance. Meanwhile, the film-maker sways between the role of spectator and actor, between guide and visitor. Sokurov's own approach to the film's staging of history finds justification and legitimization in Custine's criticism of the theatricalization of Russian court life:

The more one sees what court life is, the more one sympathizes with the lot of the man who is obliged to direct it – especially the court of Russia. It produces the effect of a theatre where the actors spend their lives in dress rehearsals. No one knows his role and the day of the presentation never arrives as the director is never satisfied with the performance of his subjects. Actors and directors thus waste their lives preparing, correcting, endlessly perfecting their interminable comedy of society.

(Kohler 1980: 81)

The Narrator remains vague and passive in his defence of Russia from Custine's attacks. He guards Custine from intruding into the past if there is a danger of his presence being inappropriate, and hurries him on to prevent him from seeing the future (for example, the Revolution and World War II). He often repeats Custine's words with an ironic intonation in his voice, yet he never contradicts, argues or offers an alternative view to Custine's assessment of Russia as a country without a national identity. This stands without contradiction, as the Narrator's voice accompanies and counterpoints Custine's intonations but never engages him in a dialogue, thus confirming Custine's judgement that Russia has no ideas and no opinions: 'Russia is a nation of mutes […]. Nothing is lacking in Russia… except liberty, that is to say life' (Kohler 1980: 118).

Custine raises two issues here: the first is that of the passivity – partly linked to barbarity, partly to orthodoxy – which makes the people subject to a rigid discipline that they do not question, offloading all responsibility onto the tsar and his wife. Indeed, Custine's description makes the tsar appear like a strapped-up, uniformed man, and the tsarina as a sad and thin creature (Buss 1991: 61–62); the second issue is the overwhelming responsibility of the enlightened autocrat. It is in this context that Custine changes his view on representative government, wherein some responsibility would engage and activate the people, and in which we have to place Custine's comments on the people who have become disciplined, mechanized automatons without any free will or thought, comparing them to 'regimented Tartars' (Buss 1991: 63), which leads him to reverse his rejection of absolute monarchy.

In *Russian Ark*, the character of the Marquis de Custine finds himself outside the Hermitage at some point in the first half of the nineteenth century, as suggested by the Narrator's comments on the costumes. Custine abhors Russia's despotism and begins by commenting on Peter the Great, comparing him to the despots Alexander of Macedon and Timur (Tamerlane) when discussing how Peter had his own son Alexis killed. At this point, the Narrator tries to contradict Custine, pointing out that Peter taught Russia how to enjoy itself, but that deeds know better than words: as the visitors move along the corridors and into the Hermitage proper, Peter is whipping one of his generals.

Custine is not impressed by the Russian fêtes, which he sees as poor imitations of European balls. He dislikes Petersburg, the 'chimera' on the swamp. Custine believes only in European culture, stating that the orchestra in the Hermitage Theatre must be European, and Mikhail Glinka (1804–1857) must be a German composer as the Germans write the best music. He clearly invests no confidence in Russia as a country with its own culture. And quite rightly so: what he sees during his tour of the Hermitage is exclusively western art. Russia has no identity of its own and needs to borrow a cultural heritage from Europe in order to define itself: 'One has to come to Russia to see the result of this terrible combination of the intelligence and the science of Europe with the genius of Asia' (Kohler 1980: 95). Even Custine's obsession that St Petersburg will be destroyed or perish is adopted by Sokurov in the final images of the film:

The Baltic Sea with its sombre shades and its little travelled waters proclaims the proximity of a continent deprived of inhabitants by the rigours of the climate. There the barren shores harmonize with the cold and empty sea. The dreariness of the earth, of the sky, and the cold tinge of the waters, chill the heart of a traveller.

(Kohler 1980: 40)

Finally, and visually, the fragility of the city is also something Custine notes: that despite the granite and marble, this city may 'disappear like a soap bubble in a breeze [...] the disappearance of Petersburg can be foreseen; it can happen to-morrow in the middle of the triumphant shouts of its victorious people' (Kohler 1980: 65).

Custine's tour, begun under Peter the Great and Catherine the Great (who is rehearsing a play in the Hermitage Theatre), cuts across different periods, in which present-day visitors to the museum mingle with historical characters. Custine claims that his mother was an artist and he himself was a diplomat, deluding us about his biography. In reality, Custine was an isolated and lonely man, rejected by society, with a mother who had been the mistress of many writers, but no sculptress. Custine's ambition as a diplomat and writer guide him in this romanticized version of his biography.

During his walk through the Hermitage, Custine dismisses most of the artworks he sees as cheap imitations of the originals in European art collections. Russia is a country without ideas, without authority; this explains the lack of authority in the Narrator's voice. Russia imitates out of laziness and a lack of initiative: 'Every Russian is a born imitator' (Buss 1991: 135) and 'the Russians have invented nothing and [...] they can copy without improving what they copy' (1991: 228). If Russia cannot produce a cultural heritage itself, neither can it master its space or form a national identity: 'Space is always too vast for them to form. That is the advantage of a country where there is no nation' (Kohler 1980: 78). While Custine is dismissive of Russia's society, astutely observing its passivity and submissiveness (which he attributes to its autocratic rule as much as to its national temperament, which makes people predisposed to such obedience and compliance with orders), he finds nothing natural in the social events he attends and nothing original or impressive in the cultural objects he sees. Instead, he comments on the disregard for human life, both in everyday life and in the stiffness of the court.

Specifically, Custine comments negatively on the way in which the paintings in the Hermitage art collection are displayed; he voices concerns about the Petersburg light (too bright in the summer, too gloomy in the winter), but mostly about the hanging arrangements (this preoccupation is also reflected in Custine's comments in the film). Here is a longer citation from Custine's letters, a passage not included in the standard editions:

All the world knows that there are here some choice pieces, especially of the Dutch school; but I do not like paintings in Russia [...]. So near the pole the light is unfavorable for seeing pictures, no one can enjoy the admirable shading of the colors with eyes either weakened by snow, or dazzled by an oblique and continuous light. The hall of Rembrandt is doubtless admirable; nevertheless, I prefer the works of that master which I have seen at Paris and elsewhere.

The Claude Lorrains, the Poussins, and some works of the Italian masters, especially of Mantegna, Giovanni Bellini, and Salvator Rosa, deserve to be mentioned.

The fault of the collection is, the great number of inferior pictures that must be forgotten in order to enjoy the masterpieces. In forming the gallery of the Hermitage, they have gathered together a profusion of names of the great masters; but this does not prevent their genuine productions from being rare. These ostentatious baptisms of very ordinary pictures weary the virtuoso, without charming him. In a collection of objects of art, the contiguity of beauty sets off the beautiful, and that of inferiority detracts from it. [...]

If the Rembrandts and the Claude Lorrains of the Hermitage produces some effect, it is because they are placed in halls where there are no other pictures near them.

(Muhlstein 2002: 350)

If Custine returns from his visit to Russia with a revised view of the social order, favouring people's empowerment over a system where the individual is reduced to a cog in a wheel, not only disempowered, but also paralysed – and seeing Russia as a weak imitation of European culture, then Sokurov places Russia clearly on the side of Europe, characterizing its prime value as an imitator, even protector, of European culture, and rejecting the idea of its

continuous striving to mediate between Europe and Asia (or even dominate Asia). Russia has no special mission to bridge European and Asian cultures, as entertained by Nikolai Berdiaev, but should hark back to the glorious past of European dominance and influence in the eighteenth and nineteenth centuries. Sokurov's deliberate apolitical stance in his earlier films, as well as his concern with aesthetics, with photographic and frame compositions, and with recording paintings to capture both content and texture, here leads to a film that seemingly refrains from political commitment, yet indirectly makes a crass political statement: that Russia had its glory in the past, while its present is void, empty, non-existent. For Sokurov, Soviet Russia had no culture and only played a shadowy role as protector of the country's cultural heritage. Yet we need to look further at the art collection which Sokurov uses to tell this different story: at the images in the frames.

THE HERMITAGE MUSEUM: THE ARK OF ART

Here we are destined by Nature
To cut a window into Europe [...].

(Aleksandr Pushkin, 'The Bronze Horseman', 1833)

The city of St Petersburg, founded by Peter the Great in 1703, was designed – in the words of Venetian philosopher Francesco Algarotti – to open a window for Russia: a window onto Europe, as often implied, although Peter was first and foremost concerned with access to the sea so that he could turn his country into a seafaring nation. Peter the Great was also the founder of the first museum in St Petersburg, the Kunstkamera, whose foundation was laid in 1719, and which opened in 1727 with a display of scientific objects.

The Hermitage collection was founded in 1764 by Catherine the Great. It is one of the oldest and largest art collections in the world, and today also comprises the building of the Winter Palace (the former imperial residence). Since the collapse of the Soviet Union the museum has been directed by the Armenian-born orientalist Mikhail Piotrovskii (b. 1944), who makes an appearance in the film. He has actively pursued an engagement with the West by opening branches of the Hermitage abroad, notably in London (at Somerset House, 2000–07), Amsterdam and Las Vegas. Previous directors include Piotrovskii's father, the orientalist Boris Piotrovskii (1908–90), who was the museum's director from 1964 until his death, and who is known for his work on the biblical Kingdom of Van, or Ararat (Urartu), in modern-day Armenia. The Georgian-born orientalist Hovsep Orbeli (1887–1961), also known for his work on Urartian culture, was appointed in 1934 and steered the museum through such difficult times as the Leningrad Siege (1941–44) and Stalin's reign. It is curious to note that the three directors of the Hermitage were all orientalists from the Caucasus region, and in particular Orbeli significantly enriched the Hermitage's collection with artefacts from Urartu. However, the part of the collection shown in *Russian Ark* is exclusively European.

In the architectural ensemble on Palace Embankment, the Winter Palace [Zimnii dvorets] is located nearest to Palace Bridge [Dvortsovyi most] when facing the complex from the River Neva. The Small Hermitage, the Old (Large) Hermitage – with the New Hermitage hidden behind – and the Hermitage Theatre continue the ensemble of buildings along the Neva enfilade towards Trinity Bridge [Troitskii most]. The ensemble was designed in the Italian baroque style by the architect Francesco Bartolomeo Rastrelli (1700–71), who had moved to St Petersburg with his father, Peter I's court architect Carlo Bartolomeo Rastrelli (1675–1744), in 1716. Giacomo Quarenghi (1744–1817) – the famous Italian architect who had designed the English Palace in Peterhof and settled in Russia in 1783, is responsible for the design of the Hermitage Theatre (1783–88), the only building in the ensemble that has remained almost entirely intact in its original structure. The Winter Palace and Hermitage complex is thus entirely the work of Italian architects.

Rastrelli designed the Winter Palace (1757–62) to function as the winter residence for the tsar, and it was used for this purpose until 1904, when Nicholas II took permanent residence in Tsarskoe Selo, just outside the city.

Particularly notable in the Winter Palace is the Jordan Staircase, restored by Vasilii Stasov (1769–1848) after the fire of 1837, to the original design by Rastrelli. Quarenghi designed the Raphael Loggias (1792), the Great (Nicholas) Hall (1790) and St George Hall (1787–95), the latter two restored by Stasov, who also reconstructed the Armorial Hall, and added the Concert Hall and the Portrait Gallery. Auguste de Montferrand (1786–1858), chief architect of St Isaac's Cathedral (1819–58), designed the Field Marshall's Hall and the Memorial Hall of Peter the Great, also known as the Small Throne Room.

The Small Hermitage, built for the leisure time activities of the empress, was attached to the east of the Winter Palace between 1764 and 1775 by the French architect Jean-Baptiste Vallin de la Mothe (1729–1800), who had impressed the empress with designs for the Academy of Arts, and by the German architect Georg Friedrich Veldten (1730–1801), an assistant to Rastrelli. The Small Hermitage links to the classicist buildings of the Old (Large) Hermitage (1771–87), also built by Veldten, and the New Hermitage (1842–51), purpose-built as a museum under Nicholas I to the design of Leo von Klenze, the German architect and mastermind of the Glyptothek and Pinakothek in Munich. The building has an amazing portico for the entrance onto Million Street, which was designed by Aleksandr Terebenev (1815–59).

A fire devastated the Winter Palace and the Hermitage on 17 December 1837. The tsar had 6000 people work permanently on the reconstruction, in conditions that show a total disrespect for human life (indeed, this is also true for the construction of the city under Peter the Great). With outside temperatures as low as –30°C, the interiors were heated to 30°C so that the plaster would dry, and the loss of life in this enterprise was extremely high (Buss 1991: 39; Ippolitov 2006). Custine's visit in 1839 therefore comes after the fire, but at a time when most of the buildings had already been restored. The rooms in the Old Hermitage towards Palace Embankment were refurbished by Andrei Stakenschneider (1802–65) in a classical style, while von Klenze designed the rooms overlooking Million Street.

The bulk of the Hermitage's collection of paintings was acquired by Catherine the Great, who in 1764 bought some 225 paintings from the collection of Johann Gotzkowski in exchange for a debt he had to Prince Vladimir Dolgorukii. This collection included paintings by Rembrandt Harmenszoon van Rijn, Peter Paul Rubens, Anthony van Dyck, Frans Hals, and other Flemish masters of the late seventeenth century. In 1769 she acquired the collection of the Minister of Saxony, Count Heinrich von Brühl, which consisted of over 600 paintings, including Titian's first masterpiece, *Flight into Egypt* (1507), exhibited at the National Gallery in London for the first time outside Russia in 2012. From Paris, Catherine acquired the collection of Pierre Crozat in 1772, including Raphael's *Madonna with Beardless St. Joseph* (1506), Giorgione's *Judith* (1504) and one of Titian's *Danaë* (1553–54), as well as works of the Flemish masters, and paintings by Nicolas Poussin, Claude Lorrain and Antoine Watteau. She later acquired a collection including more Rembrandt and van Dyck paintings from Sir Robert Walpole in 1779. In 1768 she added a set of drawings purchased from the Brussels collector Johann Ludwig Joseph von Cobenzl. The acquisition

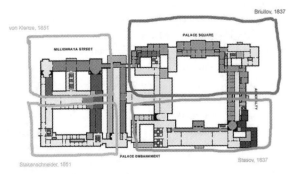

Figure 4: Map of the Winter Palace
and Hermitage complex.

of the collection from the English banker John Lyde-Brown included Michelangelo's *Crouching Boy* (1530), which remains to date the only sculpture by the artist in Russia. The collection of Count F. Baudouin arrived in the Hermitage in 1781 through the mediation of Melchior Grimm, who also assisted Catherine in obtaining the libraries of Voltaire and Diderot. All this was a major attempt to bring Russia to the same level of cultural heritage as European monarchies, and to satisfy the cultural aspirations of the foreign-born empress Catherine II, born Sophie Friederike Auguste von Anhalt-Zerbst-Dornburg.

For *Russian Ark*, Sokurov restricts his journey to the Hermitage Theatre, the Neva-facing rooms of the Old and Small Hermitage, and the Winter Palace. The journey begins at the stage entrance to the Hermitage Theatre, located at the back of the building towards Million Street. The path goes through the basement and up a narrow staircase to the backstage of the theatre, and from the stage into the auditorium, exiting via the official foyer, designed by Alexandre Benois in 1904 and located on the bridge connecting the theatre with the Old Hermitage. The first rooms in the Old Hermitage are the Raphael Loggias, designed after the gallery in the Vatican's Apostolic Palace and decorated with frescoes by Raphael and his team.

Russian Ark's camera moves into the Small Italian Skylight Room and the Gallery of the History of Ancient Painting, passes sideways along the Jordan Staircase to the New Hermitage, and enters the Van Dyck Room, Rubens Room and the Room of Netherlands Art of the Late Sixteenth and Early Seventeenth Centuries, which face the back of the building built by von Klenze in 1851 (the rooms towards the river façade were largely designed by Stakenschneider in 1851 and are excluded). Taking a right turn into the Tent Hall and Rembrandt Room, we move towards the Council Staircase, where the visit to the museum ends.

With the camera. we leave the Old Hermitage and enter the Small Hermitage, where Custine accesses the Pavilion Hall (designed by Stakenschneider), which he leaves via the Hanging Garden of the Small Hermitage (also designed by Stakenschneider) before re-entering the building by the St George Hall (designed by Quarenghi), which is part of the Winter Palace. The Winter Palace is the imperial residence, and we follow Custine through the Armorial Hall and the Memorial Hall of Peter the Great, or the so-called the Small Throne Room (designed by Montferrand), where we meet the museum directors, before passing through the Field Marshalls' Hall towards the Portrait Gallery of the Romanovs into the Concert Hall. We then enter the Great (Nicholas) Hall (another design by Quarenghi) and exit via the Jordan Staircase of the Winter Palace (accomplished by Rastrelli). The entire back part of the Winter Palace – the façade looking onto Palace Square containing the private rooms of the imperial family – elides the camera. Thus most of the buildings and interior designs we see in the film were created by European (more precisely, French and Italian) architects, with the sole exception of Stasov, who worked mainly on reconstruction.

What Custine sees during his tour of the museum is exclusively western art. Following Custine's criticism of Russia's tendency to imitate, Sokurov denies Russia the right of its own culture, its own voice and its indigenous tradition. Russia is a ship that is never going to dock, neither in Europe nor in Asia. Russia has seen its glory under European influence, and it is only thanks to Europe that Russia has made an impact on world culture and history. The use of Custine's comment as a non-contradicted, 'authorial' voice (the author's voice, expressed through the invisible Narrator, has no authority) defines 'Russian cultural heritage' as the European collections in the Hermitage, and 'Russian history' as the years 1689 to 1913.

The Hermitage functions as an ark of cultural heritage, containing one of the largest collections of paintings in the world and the treasures of the Romanov empire. In *Russian Ark*, Sokurov draws exclusively on the periods in Russian history when the country was most exposed to European influences. He excludes the time before Peter the Great – the tsar who opened Russia to the West and founded the city of Petersburg as the 'window onto Europe' – and ends his account with the last tsar, Nicholas II, thereby erasing 80 years of Soviet rule and ten years of post-Soviet Russia, as well as eliding most of the nineteenth century, while at the same time offering a 'powerful justification of the controversial canonization of the "martyred" Nicholas II' (Kachurin and Zitser 2006). Sokurov refuses to see continuity between the Russian empire and Soviet rule, or a link from Kievan Rus to the Russian empire; moreover,

he is not at all concerned with the politics of the time. Sokurov thus renounces the twentieth century as unworthy of depiction and lacking in cultural value; its only task lies in preservation. Indeed, the choice of historical figures is very much motivated by their contribution to the preservation of cultural history. But we shall first look at the treasures and paintings which are eyed closely by the camera, and which draw the attention of the visitor, Custine. We shall then return to his comments in the film analysis and offer a brief art-historical introduction.

The Small Italian Skylight Room contains a nineteenth-century lapis lazuli vase and matching tables, as well as an 'Empire' style vase and chandeliers by Andrei Voronikhin (1759–1814), the architect of the Kazan Cathedral in St Petersburg. The artworks in the room, which is lit naturally through the skylight, are largely Italian Renaissance paintings. Singled out in the film are Tintoretto's *Birth of John the Baptist* (1550), which covers the story from Luke (1: 57–80) about the birth of John the Baptist. According to Luke, John's father, Zachary, had lost the ability to speak as a punishment for not believing that he would have a son. After the birth of a son, he wrote down that the boy should be baptised with the name of John, as God had ordained; thereafter Zachary regained his speech. The painting positions the child's mother in the background and Zachary in the foreground, while the viewer's attention is focused on the midwives and the wet nurse. Calmness emanates from the scene: even the chicken and the cat in the foreground – natural enemies, and symbols for greed and cruelty respectively – are restful. The painting came to the Hermitage from the Crozat collection.

The room contains other Italian baroque paintings that appear in the field of the camera's vision: Massimo Stanzione's *The Death of Cleopatra* (1630–40), a painting not in fact acquired until 1968, showing the dying empress Cleopatra, mistress to Mark Antony, who was married to the Roman emperor Octavian's sister. When Antony lost the battle for power over the Roman Empire, he fled to Egypt and committed suicide. Threatened with captivity, Cleopatra had a venomous snake brought to her and sacrificed her life to avoid suffering. This worldly story is displayed next to a painting with a profoundly Christian theme: Lodovico Cardi's (Cigoli) *The Circumcision of Christ* (1590), acquired in 1825, which highlights the Jewish beginning of Christ's life, as demonstrated by the ritual of his circumcision: 'On the eighth day, when it was time to circumcise the child, he was named Jesus' (Luke 2: 21). Carlo Dolci's *Saint Cecilia* (1640s), acquired between 1774 and 1783, also portrays a religious theme. Cecilia was a martyred Christian who converted her husband Valerian to Christianity when she heard God's voice sing within her. Hence, she is the patron of musicians, and in the painting she is shown with a quiet facial expression playing the organ. The camera glances in passing at Guercino's *Assumption of the Virgin Mary* (1623), which was acquired from the Tanari collection in Bologna in 1843. A less dramatic and mundane painting is Francesco Maltese's *Still Life with Eastern Rug* (1650s), acquired between 1774 and 1783, and showing a heavy Isfahan rug in yellow, red and blue hues, with a dish placed on the table that it covers.

The Gallery of the History of Ancient Painting, leading to the Staircase of the New Hermitage, contains a display of statues. Here we find Antonio Canova's *The Three Graces* (1813–16), a white marble sculpture created during the Marquis' lifetime and brought to Russia by Empress Josephine's grandson Maximilian. It shows the three figures of antiquity embodying female beauty. Traditionally, they are shown facing each other, with one having their back to the viewer; however, Canova has them stand in a line, but with their faces turned towards each other. On the gallery around the staircase, the camera focuses on another white marble sculpture, this time of Psyche, identified by the butterfly attached to her shoulders (Psyche's traditional depiction); this is the work of the little-known Italian artist Gennaro Cali (1799–1877), *Psyche Abandoned*, which was created in 1832.[4] This sculpture shows Psyche stretching her arms for help after her lover Cupid has disappeared. Despite a prohibition to look at him, Psyche lit an oil lamp to see whether he was a monster (as her sisters had suggested), only to find that he was the god Cupid. Psyche would thus draw the jealousy and revenge of Cupid's mother, Venus. Both sculptures touch on non-religious subjects, drawing on mythology for the subject of beauty instead, namely the absolutes of beauty represented by the graces – Euphrosyne, Aglaea and Thalia (the daughters of Zeus) – and Psyche's beauty, which ultimately makes her immortal (according to the myth, she also procured the ointment for beauty from Persephone).

The following suite of exhibition halls consists of three rooms in the New Hermitage to the back of the building facing Million Street: the Van Dyck Room, the Rubens Room and the Room of Netherlands Art of the Late Sixteenth and Early Seventeenth Centuries. Anthony van Dyck's *Madonna with Partridges* (*Rest on the Flight into Egypt*) (1630) was re-hung from the Room of Flemish Art to locate it on the camera's path. Acquired from the Walpole collection in 1779, it shows the flight of Joseph and Mary to Egypt with the infant Christ. As the parents rest, the child is entertained by dancing angels and cherubs, thereby adding an earthly dimension to the life of Christ. The place is rich in flora and fauna, with a range of symbolic animals and plants, from a parrot and flying partridges, to a sunflower, a lily and a pomegranate, as well as the sin-ridden apple tree. Rubens' *Feast in the House of Simon the Pharisee* (1618–20), also from the Walpole collection, shows a scene from Luke, which depicts a sinner entering the house of Simon the Pharisee during a visit from Jesus:

> A woman in that town who lived a sinful life learned that Jesus was eating at the Pharisee's house, so she came there with an alabaster jar of perfume. As she stood behind him at his feet weeping, she began to wet his feet with her tears. Then she wiped them with her hair, kissed them and poured perfume on them.
>
> (Luke 7: 37–38)

Simon judged Jesus for his benevolence and for allowing a sinner to touch him. Rubens juxtaposed the material concern of Simon the Pharisee to Christ's absolution of sin. Located in the Tent Hall is Frans Mieris' *Lady at her Toilet* (1659), acquired in 1769 from von Brühl, portraying the life of the wealthier classes of society in their daily routine rather than offering a posed portrait.

In the Spanish Cabinet hangs El Greco's *Peter and Paul* (1587–92), donated to the museum in 1911, and depicting the two Apostles together: a meek and humble St Peter is shown as the holder of the key (the rock on which the church is built), while St Paul reads from the scripture and is clearly more a teacher of the Christian faith. This predisposition is reflected in the golden and red colours of their garments.

From here we move into the Rembrandt Room, still in the New Hermitage. Rembrandt's *Danaë* (1636), part of the Crozat collection, shows the virgin Danaë, who gave birth to Perseus after being seduced by Zeus, who appeared in the guise of a shower of gold. It has become a special treasure of the Hermitage ever since its restoration (completed in 1997) following an attack with a razor and acid in 1985 that effaced almost the entire figure of Danaë, so that it is not at all obvious to what extent this is still an 'original' painting. Danaë is here depicted not as a Greek princess, but rather as a beautiful contemporary woman of Rembrandt's time. Rembrandt's *Abraham and the Three Angels* (late 1630s), acquired under Catherine the Great, depicts a scene from the Old Testament (Genesis 18: 1–15), in which Abraham receives a visit from the Lord in the shape of three angels, who announce that his wife, Sarah, although already an old woman, will bear him a son. The camera also lingers on *Timothy and Lois* (1654) by Willem Drost, a young Dutch painter close to Rembrandt. The painting was acquired with the Crozat collection and attributed to Rembrandt, but was identified as the work of Drost in 1924. The painting shows the young Timothy reading the Bible with his grandmother Lois, and draws on the Old Testament (Second Epistle of Paul to Timothy 1: 5), which tells of Timothy being praised by the Apostle Paul for his knowledge of the Holy Scriptures. Both reading and faith had been imparted to him by his mother, Eunice, and his grandmother Lois, thus highlighting the significance of godly mothers in inspiring in a child the ability to read and understand the scriptures in a spiritual manner.[5] The camera also pauses on Rembrandt's *Abraham's Sacrifice of Isaac* (1635), based on the story from Genesis (22: 1–13) of God testing Abraham by demanding the sacrifice of his son, Isaac. The painting shows Abraham as he is about to kill his son before an angel stops him. The tension is captured in Abraham's face as he passes this test of faith. Finally, the camera lingers on Rembrandt's *The Return of the Prodigal Son* (1686), which arrived with the collection of Count Antoine d'Ancezune in 1766. The painting follows Luke (15: 11–32) in his telling of a father's reunion with the son who had left home and sinned, but who is forgiven when he returns. The theme of redemption through repentance

is important in this work, as brothers and sisters are shown as silent witnesses, contradicting Luke's version, in which the elder brother protests.

Custine leaves the exhibition rooms and finds himself on the Council Staircase, chased out of the museum by the guards. Having lost his sense of direction, he enters a room with empty, hoar-covered frames. The room represents the Hermitage during the Siege, when paintings were evacuated to the Urals and the rooms were used to make coffins for the dead. Custine knows nothing of the catastrophes of twentieth-century Russian history and returns to the historical part of his journey, entering into the Pavilion Hall that forms part of the Neva-side façade of the Small Hermitage.

The Hermitage's collection of eastern, oriental artefacts and paintings is omitted. The focus is on the Italian baroque, the Flemish masters and Canova's sculptures, singling out artworks with a religious theme. There is almost a rhythm that can be observed here, with four religious paintings of the Italian baroque, followed by a secular still life (Maltese), another four religious stories (this time of the Flemish school), a portrayal of a secular scene (Mieris) and four religious motifs to conclude.

HISTORY AND THE WINTER PALACE

[Sokurov] radically subverts the conventions of the 'heritage film' by making its viewers constantly aware of the artificial historical representation.

(Christie 2007: 244)

History and its players

In compressing 300 years of history into 90 minutes of reel time, Sokurov folds time in curious ways. Whilst offering a chronological survey of sorts, he actually overlays different epochs and different ways of representing history through pictorial representation and re-enactment.

On the one hand, there are enacted, performed scenes from the life of the Russian tsars: Peter the Great whips his general to the dismay of his wife, Catherine I; Catherine the Great attends a rehearsal in the theatre; Nicholas I receives the Persian emissaries to accept an apology for the murder of Russian diplomats, among them the poet Aleksandr Griboedov, by a mob in Tehran; and Nicholas II has dinner with his wife, Alexandra (Alix), and his children. This sequence of historical events ends with the finale, the last ball in 1913, on the eve of World War I, celebrating the tercentenary of the Romanov dynasty. Moreover, time passes at the speed of breath: the Empress Catherine is a young woman during the rehearsal at the Hermitage Theatre, while a few rooms later she is an old lady, running off into the Hanging Gardens to get some fresh air.

The choice of episodes from Russian history obviously has to be restricted and a selection made. But what has Sokurov excluded? As Isabel de Keghel (2008: 82) has observed, Sokurov focuses attention on those tsars who played an important role in the creation and development of the Hermitage as a museum: the founder of the city's first museum, the Kunstkamera, Peter the Great; the Hermitage's founder, Catherine the Great; Nicholas I, who oversaw the restoration after the fire and created the New Hermitage in 1852; and Nicholas II (with a minor appearance) as the last guardian of the museum and the tsar who moved the imperial residence from here to Tsarskoe Selo.

For the film-maker, Russian history begins with Peter the Great (who ruled 1682–1725), the founder of St Petersburg, building the city as a window onto Europe and forming a passage for Russia to the Baltic Sea, thereby turning the country at large into a seafaring nation that could compete with other European empires. Peter 'westernized' the country, introducing European culture and know-how to Russia, alongside administrative reforms that allowed social advancement on the basis of service for the state rather than birth. In 1721, he would turn Russia

into an empire, and thus himself into an emperor (rather than a tsar). With the onset of westernization, a dichotomy unfolded for Russia's role in the world and her national identity, geographically positioned between Asia and Europe, East and West, modernization and 'barbarity', or lack of civilisation. Yet Peter's reign was far from peaceful, being a time ridden with territorial wars and political persecution that included the execution of his son, Alexei. Peter's wife, Catherine I, succeeded him (reigned 1725–27), followed by his grandson Peter II (reigned 1727–30), finally passing the throne to Anna (reigned 1730–40), the daughter of Peter's co-ruler, Ivan V, when no other male heir of the Romanov dynasty remained. Anna continued the westernization process and the architectural development of the city, and also ensured stability. Her successor, Ivan VI (1740–1741), was proclaimed tsar at the age of ten but overthrown by Peter's daughter Elizabeth. She had him imprisoned in Schlüsselburg, ordering him to be killed should an attempt be made to overthrow the ruler. This is exactly what would happen under Catherine the Great in 1764 and is of great interest to Custine, who visited Schlüsselburg during his journey. Elizabeth I (reigned 1741– 62) was the second daughter of Peter the Great and his wife, Catherine. She continued westernization by founding academies and developing St Petersburg's baroque architecture with works by Rastrelli, adding to the Winter Palace, Peterhof and Tsarskoe Selo, and staging gorgeous balls. She remained unmarried and designated her nephew Peter II as successor, having ensured his marriage to Sophie Anhalt-Zerbst-Dornburg (Catherine II, the Great), and seeing the birth of a son, Paul. Peter was killed a few months into his rule in a conspiracy to put Catherine on the throne. None of this historical turmoil and the development of St Petersburg as a capital with architectural, cultural and familial relations to Europe is of interest to Sokurov. Instead, the film jumps over the period from 1725 to 1762, eclipsing the long and peaceful rule of Elizabeth – which is significant for Petersburg's development – and moving straight to Catherine the Great (ruled 1762–96), whose politics of expansion towards the south and east added to Russia's power. Her imprint of classical style is visible on St Petersburg's architecture, while her spirit of enlightenment informed the increased influence of western culture and modern values (for example, with the establishment of social and educational institutions, including the Smolny Institute for Women). Her long rule interests the film-maker so much that she appears twice in the film, both as a young empress involved in a theatre rehearsal and in later years entertaining children. As Katia Dianina (2004: 633) has pointed out, Catherine the Great played a significant role in the development of St Petersburg's cultural life as a way to assert her role as an enlightened monarch: 'For a prestigious collection like the Hermitage's was sure to represent Catherine as an enlightened monarch and, by extension, Russia as an enlightened society'.

During her reign, Catherine developed social and cultural life at great financial expense, deploying what Dianina (2004: 634) calls a 'calculated strategy of empowerment'. She not only founded what would become the world's largest art collection, but also accumulated an enormous book collection for her library, starting with the acquisition in the 1760s of 44,000 volumes, including the libraries of the former director of the Academy of Science, Johann Korf (1764); the historian Prince Shcherbatov (1791); of Count Lanskii (1784); and, most significantly, of Diderot, who was forced to sell his books in 1765, but was allowed to keep the collection until his death (it was transferred to the Hermitage in 1785). She also acquired Voltaire's library after his death. Catherine initiated literary salons around the court, and enjoyed theatre and performance, writing plays herself and with her court circle that were often staged for the small inner circle in the Hermitage Theatre. Although Catherine founded the Academy of Arts, she never acquired any works from there. Catherine used her cultural activities to promote her image as an enlightened monarch, but also to maintain her German and European connections (after all, she was not Russian-born), and to develop society by setting high cultural standards.

The Hermitage of Catherine the Great led a double life in imperial St. Petersburg. It was a superstructure that bridged state and society. It was a new kind of 'contact zone,' in which discourses private and public, official and unofficial, foreign and local, imagined and real, coexisted. It was a liminal space where art and authority met.

(Dianina 2004: 631)

The notion of the Hermitage as a liminal zone is particularly appropriate for its representation in the film, namely as an ark that already formed an island of cultural values within a larger environment at the time of its foundation.

Catherine's rule was followed by Paul I (1796–1801), who was assassinated to bring to the throne Alexander I, the eldest of his ten children. An absolute ruler, who swayed in his allegiance to Napoleon and made significant territorial conquests in the Caucasus, he is not depicted in the film. Neither is the Decembrist uprising, through which the military tried to stop Alexander's younger brother Nicholas from acceding to the throne after the elder Konstantin, had refused it. Both the conspiracy of the murder of Paul I and the Decembrist uprising have been popular historical subjects for film-makers and writers alike.[6] Sokurov performs a jump from Catherine to the autocrat Nicholas I (1825–55), who began his rule by ending the wars in the Caucasus and Turkey, but ended his reign with Russia's defeat in the Crimean War. He won the Russo-Persian War (1826–28), sealed with the Treaty of Turkmenchay on 10 February 1828, which gave the Russian empire control over most of the Caucasus, including modern-day Nakhechivan, Armenia and Azerbaijan, as well as Iğdır Province. Aleksandr Griboedov was dispatched to Tehran as ambassador, but due both to the political climate and to his disregard for local customs, the Russian embassy was attacked by a mob and its staff decapitated on 30 January 1829. The shah's grandson, Khosrow Mirza, was sent to St Petersburg to apologise and present the Shah Diamond to the tsar. Nicholas' wife was Alexandra Fedorovna, Princess Charlotte of Prussia, and they are the rulers whom Custine actually met when he visited in 1839. Nicholas' expansion of the Russian empire to its largest size, as well as his attempt at modernization by building a railway and other projects, were paid for with people's lives. Following Slavophile ideas, he denied autonomy to the regions and governed with a firm hand, promoting Russian culture, literature and ballet rather than pursuing the import of European artefacts. Mikhail Glinka's *A Life for the Tsar*, which premiered in 1836 at the Great Stone Theatre [Bol'shoi kamennyi teatr] – the predecessor of the Mariinsky Theatre – was composed under his reign, and echoes the patriotism and nationalism of the time. It tells the story of Ivan Susanin, a patriotic hero who gives up his life for the tsar by leading the advancing enemy (the Poles) astray.

Also not depicted in the film is the liberal tsar Alexander II (1855–81), who took Russia out of the Crimean War by making significant compromises following the loss of Sebastopol. He is credited with the emancipation of the serfs in 1861, and whilst such reforms cement his liberal reputation, his rule also saw a significant increase in exiles and the prosecution of the political opposition, in particular the emerging socialist and anarchist groups, which ultimately led to his assassination. His wife, Maria Alexandrovna (Marie of Hesse), gave her name to the Mariinsky Theatre. Alexander III (1881–94), a more conservative ruler, who married Princess Dagmar of Denmark, is also not shown in the film. Instead, we jump once again to a notorious and autocratic ruler, Nicholas II (1894–1917) – the last tsar – whose rule not only ended in the collapse of the empire, but also saw massive losses in the Russo-Japanese War and the brutal oppression of the popular uprising of 1905 known as 'Bloody Sunday'. His wife, Alexandra Fedorovna (Alix of Hesse), appears in the film with their children, the daughters Olga, Tatiana, Marie and Anastasia, and the haemophiliac tsarevich Alexei.

The film ends with a ball held in 1913, usually described as the last great ball in the Winter Palace. According to historical records, the last ball in the Winter Palace took place on 11–13 February 1903, and was a costume ball where the guests donned seventeenth-century style garments. Many remember it as the 'last ball' because of its extravagance.[7] Due to the delicate political situation, the last imperial ball did not in fact take place in the Winter Palace but in the Assembly Hall of the Nobility (now the Grand Hall of the St Petersburg Philharmonic) on 23 February 1913, and was indeed organized to mark the tercentenary of the Romanov dynasty. It followed a performance of Glinka's *A Life for the Tsar*, which included the famous *mazurka*. However, the empress did not attend that event.[8]

In this way, the film focuses on the autocrats and despots of the Russian empire: a glimpse of Peter the Great, whose construction of the city cost thousands of lives; of Catherine the Great with her obsessive desire to bring western culture and art to Russia so as to make it her home, and position herself as an enlightened ruler; of the autocratic Nicholas I, who led Russia to its largest territorial conquests, but left it on the abyss of a lost Crimean War

(only for Alexander II to resolve the crisis by abandoning the Black Sea fleet); and 'Bloody' Nicholas II, who could not save the empire. The emperors who represent liberalization and progress – Alexander I and II – are eclipsed from the narrative, which aligns history entirely with Custine's comments on autocracy.

Modern people

On the other hand, there are characters from different epochs in the film, rupturing the neat chronology of the Romanov dynasty. For instance, Valerii Gergiev conducts the Mariinsky Theatre's orchestra, playing the *mazurka* from Glinka's *A Life for the Tsar*. One of the world's leading conductors, Gergiev has been principal conductor of the Mariinsky since 1988, its director since 1996, and principal conductor of the Rotterdam Philharmonic Orchestra (1995–2008), the London Symphony Orchestra (2007–15) and now the Munich Philharmonic.

Three directors of the Hermitage appear (as we have already discussed): the Armenian-born Hovsep (Iosif) Orbeli, director of the Hermitage from 1934 to 1961; Boris Piotrovskii, director of the museum from 1964 until his death; and his son, the current director, Mikhail Piotrovskii.

Two sailors from the Soviet Navy make an appearance, as do a group of Red Army soldiers marching through a room. There are contemporary visitors in one room (the Small Italian Skylight Room), including the pathologist Oleg Konstantinovich Khmel'nitskii (1920–2004), who grew up near Petrograd (as it was then called) and was imbibed with an appreciation for art early in his life. He went on to study medicine at the Pavlov Institute in 1938, worked in Leningrad throughout the Siege and became one of the leading pathologists in the country. There is also the actor Lev Mikhailovich Eliseev (1934–2015), a Leningrad theatre actor, who has made appearances in film and television, albeit largely in supporting roles. Both are personal friends of Sokurov.

The dancer Alla Osipenko, born 1932 and a student of the classical ballet teacher Agrippina Vaganova, also makes an appearance in the film. She was a ballerina at the Kirov Theatre (as the Mariinsky was called during the Soviet era), joining the company in 1950 and advancing to prima ballerina in 1954. Her life has been overshadowed by the defection of her dance partner, Rudolf Nureyev, in 1961, which for many years made her a suspect as conspirator in his defection. Following the collapse of the Soviet Union, she briefly lived in the United States but returned in 2000. She has appeared in several of Sokurov's films.

Tamara Kurenkova (born 1950) is a blind artist and sculptor. She lost her eyesight at the age of eight, and subsequently studied art with Iurii Nashivochnikov, who runs a workshop for blind artists. Kurenkova studied applied maths and worked as computer programmer before qualifying as a physiotherapist. There is also a boy, labelled 'Talented Boy' in the credits, who contemplates a picture; judging by his garments, he is a character from the late Soviet period. He seems to be a representative of the Soviet educational system, unfamiliar with the Bible and brought up in the traditions of atheism.

The people who are singled out from the crowd thus come from different social strata, but they have all lived through different periods of Soviet history and met different challenges: Osipenko of surveillance; Kurenkova of her disability; Khmel'nitskii of the Siege; Eliseev of a life in the shadow of stardom. Most importantly, there is a mix of actual representatives and figures who are enacted (Orbeli, Boris Piotrovskii, the carpenter in the room during the Siege), mixing in the 'contemporary' world of the living and the dead, resurrected through enactment. This 'ark' is timeless; a certain period may be contained in a single room, hence the importance of closing doors, to which we shall return later.

Chapter 3
Film analysis

A work of cinema is not recorded, but composed.

<div align="right">(Sokurov in Tuchinskaia 2002)</div>

THE SPECTACLE

The film begins with a black frame: the Narrator's voice recounts that he opens his eyes and sees nothing. There has been a disaster and everyone ran for safety. He cannot remember what happened. As the sound of laugher enters the background of the still black frame, the camera's lens opens abruptly, and we see a group of people dressed in nineteenth-century ball-gowns and uniforms leaving the horse-drawn carriage in a snow-covered street against the backdrop of a row of houses.

The Narrator appears to suffer from amnesia, caused by a trauma that has effaced all memory of space or time. From the costumes, he figures that this is the nineteenth century, but he is still ignorant about his location and the group's destination. As the camera retreats, an arch suggestive of St Petersburg's architecture becomes visible. The group, including two ladies with extravagant hats and furs (Rufanova and Spiridonova) – one in white and one in blue – and three 'cavaliers' in officers' uniforms (Anisimov, Barabash and Shakunov) rush forward, moving towards the camera, and passing a gatehouse as they enter the porch to an internal passage lit by streetlights. The men quibble about the women and who will take out the lady in white, as they merge with a larger group of officers dressed in uniform greatcoats. They worry whether they will be admitted, but they enter the building, passing two men standing by the entrance. Inside, the men help the ladies out of their coats; one man asks for the door to be closed as it is cold: the first 'transgression' has taken place, from outside to inside, and the two spaces are sealed off. The purpose appears to have been to bring the women into the building along with the tsar's officers. The camera turns back onto the women as they mingle with other guests, some wearing Venetian masks and moving around in an exaggerated manner, acting out some imagined roles, while the women are ushered in and rushed along the corridor.

The atmosphere is that of a hurried entrance to a ball and people running late. The costumes (although not seventeenth century) may anticipate the final (partly masked) ball at the film's end, or a readiness for the performance in the Hermitage Theatre, where we are about to move (although without the ladies). The entrance to the building is from the side of the Hermitage Theatre, and the crowd moves into the basement to ascend from there to the backstage of the theatre.

Chattering away, the noisy group advances and descends a small staircase, with the camera following them. They also appear not to know where they are going ('Where now?') and the Narrator comments on the officers' disorientation. The group moves along in semi-darkness, embracing to help each other along.

The Narrator is invisible and goes unnoticed by the crowd, which worries him. He will remain invisible to most figures in the film, as he exists apparently only for the Marquis, maybe only in the Marquis' imagination.

The camera moves along and, following the gaze of the officers, zooms in on an officer lying on the floor who is then helped up. In the internal courtyard, the music of a small orchestra is audible from a terrace, whilst warm light emanates from the rooms in the adjacent building, towards which the crowd now moves, dispersing in space and mingling with other guests wearing masks and carnival costumes. The Narrator wonders whether this spectacle has been staged for him, or whether he plays a role; he hopes it is not a tragedy.

We are clearly attending a performance and the theatrical dimension is significant for the setting of the film's scene, as it were. What we, the viewer, are about to see is a staged event, a performance of history, something that removes all pretence of authenticity or representation: it is a spectacle of history and art in which we are about to partake.

The modern museum has little choice but to accede to its place in the culture of democratic spectacle, and to embrace 'interpretation' for a mass audience that is no longer willing to accept that exhibits 'speak for themselves.' Despite this reverence for its collections, Sokurov's film is as much about the Hermitage as a 'labyrinth' in which historical time could be staged, made visible, as about its treasures.

(Christie 2012: 250)

We begin with a Bakhtinian carnival and move towards an official celebration, with which the film ends: from the temporary liberation of the carnival to the constraints and social rigour of the official event. We already see Sokurov's inclination towards incongruence, as noted by Mikhail Iampol'skii (2003: 30), who calls him a 'master of incongruence'. The non-matching and contrasting pairs of the animals on Noah's Arks are a crucial component for the film's construction along binaries, and will inform the organization of the next chapter.

The crowd moves up some stairs and into a building, along a corridor, still wondering where to go. In a narrow corridor, against a red brick wall, the Narrator spots a dark figure: a man in black, who turns towards the camera and nods at the Narrator (who is visible to him alone) before moving on. The man in the black tailcoat of nineteenth-century style – the Marquis de Custine – continues his path and asks the Narrator to tell him where they are, which city this is, even though they have not yet been introduced. Custine had hoped this might be the palace of Chambord under the Directorate, but is perplexed that he should be speaking Russian – a language he did not know, as he laconically comments. Custine walks along the corridor lined with red brick walls, suggestive of a basement rather than a palace. The Narrator's voice remains subdued, as if mumbling in or from another world, another room, and not directly addressing Custine, while the latter articulates his words clearly. Custine peers through an internal window into a room with people bent over papers and dressed in eighteenth-century costumes. The Narrator suggests he should go in, but Custine first wants to figure out where he is. He finds the Narrator's curiosity inappropriate and wants to leave: their paths must part. As Custine bids farewell, the camera moves towards the room's interior, where several men and a woman can be discerned. The Narrator regrets having missed the opportunity of a closer acquaintance with the Stranger, the foreigner. The camera observes the people inside the room: Peter's wife, Catherine, donning a red dress, is trying to calm Peter (Alekseevich) as he hits one of the generals in the face. Peter, wearing a white shirt and leather waistcoat, beats the man for a second time before the latter crawls away. We look at the scene through windows, then briefly enter through the door before we retreat. Another segment of history – the reign of Peter the Great – is enclosed and sealed in a space onto which we can look but cannot penetrate. The historical scene is enacted for observation only, as this history cannot be changed or remastered.

Concluding that foreigners never want to get involved, the Narrator decides not to disturb this scene further. In any case, all of this has already happened, so it is too late to intervene. Like in a spectacle, the Narrator/spectator is denied participation and reduced to a mere observer. As Tim Harte has astutely observed, Sokurov first positions history into a glass showcase, making it an exhibit for contemplation, before using a stage and then rooms for vignette performances:

In providing this brief foray into Russian history, Sokurov initially shoots the scene through the windows in order to communicate the historical remoteness of the scene, but with the camera movement through the doorframes, the historical, temporal barrier is broken. Crossing the threshold into the chamber, the camera moves confidently into Russia's past, simultaneously establishing this past in the present (and ostensibly eternal) moment of the film.

(Harte 2005: 49)

Custine returns to the scene, asking for guidance from the Narrator, who says this is not his century and that he does not know where he is, but that it seems they are watching Peter I. Custine challenges the Narrator about his curiosity about such a historical meeting: 'Sokurov suggests that Peter was not a just another monarch, but a ruler whose creation fits into the largest scheme possible – the story of the world's redemption' (Kachurin and Zitser 2006). Advancing along a dark corridor, Custine harshly comments on the love in Asia for tyrants, such as Alexander the Great (of Macedon), the conqueror Tamerlane and Peter the Great – a man who had his own son executed, who built a European city on a swamp, and who introduced the most primitive social order. Custine distinctly associates Russia with Asia, and rulers with tyrants over barbarians. The Narrator rejects the idea that Peter I belongs to this category of tyrants and argues that he allowed Russians to enjoy themselves: after all, St Petersburg is a European city.

Custine ascends a spiral staircase, following one of the ladies while the camera in turn follows him. They appear to be going to a party; Custine wonders why they are taking the back staircase and where everybody has disappeared to. A revolving wooden wheel suggests the movement of scenery, while ropes with weights are being pulled to lift and drop objects on the stage. Custine appears to understand where they are, while the Narrator is still unsure. He asks Custine to be careful and not betray his presence: they are intruders and not supposed to be here. The Narrator's sense of fear at being in the wrong place suggests his meekness and invisibility (not unlike Nikolai Gogol's characters dissolving in the Petersburg streets), but it also echoes Custine's sensation of being followed during his journey, suggesting a duality of character, with the Narrator as the Marquis' alter ego. The camera moves sideways between the theatre backdrops and columns on the set before catching a frontal shot of the stage itself and the actors adjusting their costumes. The music comes from an orchestra seated in the orchestra pit, playing for the performance that is about to resume. Choreographed movements are carried out by another group of actors, including an angelic figure holding an hourglass. The camera meekly bows to the floor-lights (candles) before panning over the orchestra from a slightly elevated position.

Custine comments on the 'nice little orchestra', and is convinced that they are Europeans, Italians even, whereas the Narrator assures him they are Russians. This is one of the many exchanges that reflect Custine's notion of Russia as a retrograde country with no original cultural identity. The violins play as the camera pans from the orchestra pit onto the stage, retreating further into the auditorium, where it halts behind the figure of Catherine the Great as she turns around. The camera makes another pan across the half-empty auditorium: this is a rehearsal, and Catherine

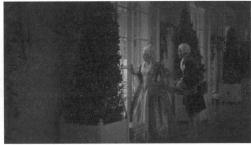

Figure 5: Peter the Great seen through internal windows.

Figure 6: Catherine the Great in the foyer of the Hermitage Theatre.

is content and applauds. The camera captures one last overall view of the Hermitage Theatre, its stage and orchestra pit, as well as the candelabras in the auditorium, which is populated by only a few ladies of the court. Catherine runs out because she needs 'to piss', and heads up the stairs in the auditorium before leaving towards and across the bridge to the Old Hermitage, premises that accommodate the theatre foyer. We enter through the back door and exit through the front door, suggesting a reversal of traditional movement. Catherine's grandee follows her, carrying her shoes and waving everybody aside. The camera follows him and Catherine, who stands by a window overlooking the Winter Canal [Zimniaia kanavka], which runs between the Neva and the Moika. Custine expresses his admiration for the eighteenth century, with its ingenious people and manners, and asks the Narrator not to contradict him. As the clock chimes, Custine follows the empress through a door that takes him into the Old Hermitage. Passing out of the theatre through the doors and across a bridge into a new building, Custine also enters into a new part of the film's composition: the museum. He comments that Russia is nothing but a theatre – something he observed in his letters: the spectacle in everything he sees, the façade nevertheless covering a lack of content.

THE MUSEUM

The camera follows Custine and turns to the left as he follows some important-looking official. Custine now begins to suspect where he is. He proceeds through another set of wooden doors into a gallery, where officials in liveries bow as he enters. Custine reminds the Narrator not to lag behind, while the Narrator is worried about making too much noise. Again and again, the Narrator wants to be invisible, not to be obtrusive; he wants to remain hidden and move along without intervening. Custine, as always, is dismissive of the remark, alleging that these people are all deaf, showing his usual disrespect for the Russian people. Custine is convinced that these actors in costumes cannot see him, and that this is all a spectacle. Indeed, he elicits no reaction from the ladies and officials standing around, but he does have the doors opened and closed behind him when entering the Raphael Loggias. The camera stays behind Custine as he wanders along this gallery and the loggias, commenting on its imitation of the Vatican: the painted reliefs were based on the sketches by Raphael. The camera closes in on some details as Custine inspects the artwork. Custine takes this copying as another piece of evidence of Russia's plagiarism and unoriginality, but also as proof that the authorities do not trust their own artists. He believes Russians copy because they have no ideas of their own and are lazy. Custine moves along a series of windows on one side and mirrors on the other, where any reflection may cause a 'film flub'. But this movement across reflecting surfaces is also part of the intersection of different times. Custine comments on the plan for a gallery of Italian masters above the loggias. The Narrator merely echoes Custine's cynical comments, claiming that the majority of tsars were Russophiles that dreamt of Italy – and that the Hermitage contains those dreams. The debate about Europe versus Asia continues here, with Sokurov defending Russia's interest in the West. Custine argues that Raphael is just not suitable for Russia.

Custine pauses, allowing the camera to get behind him as he turns right into the Small Italian Skylight Room, crowded with contemporary visitors to the museum. Custine queries the social background of these people, all dressed in contemporary garments. Custine voices his lack of enthusiasm for the 'Empire style', which emerged under Bonaparte and was fashionable in Russia; the Narrator comments that Russia fought Napoleon, not the Empire style (in other words, imitation of European fashion is more important than politics). The camera lingers on a lapis lazuli vase and table, and on another vase in Empire style, while the Narrator fills Custine in on the work of Andrei Voronikhin – another Russian imitator. Again, the Russian appropriation of style is but a pale reflection of the empire under Napoleon that Custine detests, but that was exceedingly popular at European courts of the time. As Custine is still unable to identify the historical time from which the visitors in the room come, the Narrator suggests that these are people who love the city at a time when it is no longer the capital. Custine instantly comments that clearly Moscow should be the capital rather than a chimera like St Petersburg. The comparison of Petersburg to a chimera is significant: it is a ghost ship. When Custine asks for the third time after these people, the Narrator offers to introduce him.

Thus Custine is introduced to the Narrator's friends and contemporaries, namely the doctor Oleg Konstantinovich Khmel'nitskii and the actor Lev Mikhailovich Eliseev, who rise from a bench on which they have been seated. Both are in contemporary suits and Custine is happy to talk, admitting to not having spoken to anyone in a long time.

Custine picks up some odour and identifies it as formaldehyde. Indeed, formaldehyde was first discovered as a toxic substance used for preservation by the Russian chemist Aleksandr Butlerov in 1856 (and thus not during Custine's time). What Custine smells in this scene – and only here – is a scent that emanates from him. As he moves within the gallery populated with the living, those of today, he himself is most physically a corpse immersed in and preserved by chemistry, a tangible and visible relic of the past (and not a ghostlike figure). The theme of preservation versus restoration emerges here, and will emerge again in relation to both the paintings and to history. The modern and contemporary people in the exhibition hall are dressed in a manner that is alien to Custine. He complains about their dress code (or lack thereof) and wonders which estate they belong to. He is here farthest away in time from his original visit, hence his smell as if he has risen from a cabinet of curiosities.

Custine has been in the city for an hour, but he already challenges his new acquaintances over their interest in beauty and its representation. The concept of beauty is a leitmotif in the selection of artworks and a measure of Custine's appreciation. His judgement is formed by the harmony of form rather than the spiritual content, commenting on symmetry and composition rather than the subject-matter depicted on the canvasses.

Khmel'nitskii and Eliseev draw the Marquis' attention to the details in Tintoretto's *Birth of John the Baptist*, but Custine is uninterested in this, turning his back on the painting with a comment on its acquisition. He had seen the picture during his previous visit in 1839, as it comes from the Crozat collection and was acquired by Catherine in 1772, one of the first pieces of the Hermitage collection. The men contend that this information is for specialists; they are concerned with detail, especially of the chicken and the cat in the foreground. The camera follows their gestures and closes in on the chicken that, according to the commentary, represents greed and avarice, while the cat stands for cynicism and cruelty. Both are pacified by the birth of John the Baptist. The two men are profoundly impressed by the scene, while Custine finds this 'incredibly interesting'; in other words, so boring that he turns away abruptly from the painting to go towards the opposite side of the room. The Russians are concerned with content and spirituality. The camera captures detail and the frames before getting behind Custine and the men as they cross the room. As a Catholic, Custine is outraged by the mix of paintings with secular and Christian themes: Massimo Stanzione's *The Death of Cleopatra* is displayed alongside the painting of the pious Lodovico Cardi's *The Circumcision of Christ*. Indeed, paintings of religious and secular or mythological content are hung side by side, and Custine's outrage specifically concerns the depiction of Cleopatra, considering her death less an act of self-sacrifice than one of passion. Custine's

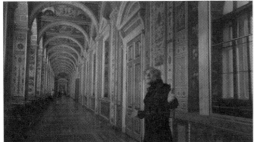

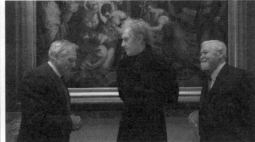

Figure 7: Custine in the Raphael Loggias.

Figure 8: Custine with Eliseev (left) and Khmel'nitskii (right) in the Small Italian Skylight Room in front of the Tintoretto painting.

impression that the Hermitage was packed with paintings, making it almost impossible to discern masterpieces: 'The fault of the collection is, the great number of inferior pictures that must be forgotten in order to enjoy the masterpieces' (Muhlstein 2002: 350) is confirmed by Dianina (2004: 635): 'This fragmentariness was underscored in the arrangement of paintings, which was essentially decorative, so as to produce "the most pleasant impression"'. Dianina (2004: 634) further supports this view with a quotation from the late eighteenth-century traveller John Parkinson, who commented on the collection as 'crowded with paintings, good and bad placed promiscuously together'.

The camera pans out onto Guercino's *Assumption of the Virgin Mary*, but Custine offers no comment here. Finally, the camera pauses briefly on Carlo Dolci's *Saint Cecilia* and Francesco Maltese's *Still Life with Eastern Rug*. The array of paintings represents a motley range of art exhibits, dealing with themes of antiquity and Christianity alongside muses and still lifes. The men are interested in the miracles, such as the appeasing effect of John's birth on the chicken and the cat, and Zachary regaining his speech. Custine's comments on the paintings are as superficial as the vague movement of the camera, which does not focus on any of the paintings on the wall and fails almost entirely to capture *The Circumcision*. The men ask him about Wagner, whom Custine claims he does not know. He asks whether he is the child who behaved so terribly with his best friend, Giacomo Meyerbeer (1791–1864).[9] Custine is exposed through this comment as a gossip, rather than a man who genuinely appreciates art. Having commented earlier on Russia's useless copying and borrowing from Europe, Custine clearly lacks an understanding of the meaning of the paintings in the way that his Russian companions demonstrate.

When capturing the paintings, the camera focuses on their frames. These pictorial frames open up a view onto other cultures. While Custine crosses the thresholds of rooms that contain different eras in performance, he never once enters the pictorial frame – the window into another world, another culture. He fails to perceive and value the meaning of the paintings or their content, which is in fact his own culture. He thus echoes the Narrator's strategy of seeing Russian culture through the eyes of Custine, creating a strange coincidence in which the Other actually moves the Narrator's eye (i.e. the German cameraman). The Narrator therefore looks at Russia as an Other rather than as the Self.

The three men leave the room and Khmel'nitskii and Eliseev see Custine off (accompanying him out of the hall), but they themselves stay behind. Custine is again amazed at how badly the people in the rooms are dressed ('Such clothing kills a man's creative essence'), while the Narrator is upset that his friends and Custine did not get on with each other. Different epochs do not correspond to each other or communicate. Custine enters the Gallery of the History of Ancient Painting with its many statues. The doors squeak as they invisibly close behind Custine, sealing off an era into 'a hermetically sealed, somewhat tomblike space' (Harte 2005: 48).

Custine goes along the gallery and walks among the marble sculptures. He comments again on Russia's European borrowing and why Russia should want to repeat Europe's mistakes. Exclaiming 'Mother!' several times, Custine is excited about the pure, neoclassical sculptures of Canova, in particular *The Three Graces* (1813–16). Custine comments on the sophisticated view of art, the sense of the material and calls Canova a 'true heir to the masters of antiquity'. Custine finds here his ideal concept of beauty represented: in all the art he sees, he looks for perfection and harmony as qualities that are absent in the reality of his life. The camera circles around the statue as Custine claims that Canova almost married his mother, who was a sculptress and lived in Rome. Canova's work, made originally for Napoleon's wife, Empress Josephine (née de Beauharnais of the House of Leuchtenberg), had been brought to Russia under Alexander I by Maximilian Duke of Leuchtenberg when he married the Grand Duchess Maria, an event Custine attended during his visit. This would explain the apparently close affinity he feels to the work.

Custine exits onto the staircase while the Narrator wonders whether he is dreaming. The great Russian poet Aleksandr Pushkin and his wife, Natalia Goncharova, ascend, arguing and quibbling as they arrive with other guests, some dressed in old-style Russian costumes and donning the headgear known as *kokoshnik*. Custine fails to recognize Pushkin, and when the Narrator points him out, Custine claims that there is nothing special about his poems. The Narrator is upset and Custine apologises if he has offended his national sympathies. Custine cannot appreciate Russian culture because he cannot read Pushkin in the original language. In his *Letters*, Custine writes at

length about Pushkin: he is aware of the duel that turned Pushkin into a 'national victim' (Buss 1991: 125). Custine knows Pushkin's writing and his style, and concludes that his poetry 'is no great merit for a man born among a still uncultured people, even in a period of refined civilization' (Buss 1991: 124). Custine once again portrays Russian society at large as barbaric, with the court and its artists trying to make it appear cultured, but claims this is done through the appropriation, imitation and translation of European originals: 'to make his mark on an ignorant nation, surrounded by enlightened ones, he only had to translate, with no expense of original thought' (Buss 1991: 124–25).

The camera follows Custine around the landing, where he has spotted a woman without a chaperone. He strikes up a conversation with this blind woman, Tamara Kurenkova, who is stroking the sculpture of *Psyche*, admiring its grace and beauty. Custine believes that she has lost her guide and then mistakes her for a member of the museum's staff. Two men in black nineteenth-century suits and white gloves overtake Custine while they argue about something. Kurenkova explains that she knows the masters well, yet she is actually not touching a masterpiece at all. This blind woman is duped again and again, and in the next room she is placed before the wrong painting. The portrayal of the blind woman as 'more sensitive' than the sighted (Christie 2007: 248) is constantly undermined: although she cannot see, she acts as a guide; whilst touching the artworks, she does not differentiate a masterpiece from a little-known piece; and although knowledgeable, she shares her interpretation with the void. She leads Custine to the next room, the Room of Flemish Masters, which is 140 paces ahead. The two men continue to argue and a third (the Spy) tells them to be quiet as he follows Custine: they are all invigilators of society and the museum. The visitors in the next room are all from the nineteenth and early twentieth century, and only Kurenkova is a contemporary figure.

Kurenkova tells him of her favourite painting, van Dyck's *Madonna with Partridges* (*Rest on the Flight to Egypt*), a painting acquired under Catherine the Great and re-hung to locate it on their path. She speaks her own lines, since the words in the script did not match what she had been told about the painting:

> I was given a text, which I read, and then I said: 'In the Hermitage they told us a different story!' I was supposed to talk about Van Dyck's painting *Madonna with Partridges* and say that it was painted for an altar and so on. But in the Hermitage we were told more than once that Van Dyck painted the *Madonna* for the Society of Bachelors, and that the partridges that fly away symbolize frivolity. I was given the telephone number of the author of the lines about the altar and I called and told him what I had heard in the Hermitage. In the end, I speak in the film a little bit with my own words about this painting […].
>
> (Bashmakova n.d.)

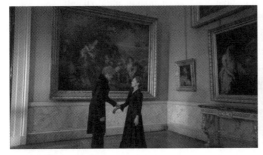

Figure 9: Custine with Kurenkova in front of *Madonna with Partridges*.

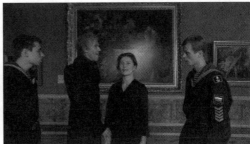

Figure 10: Custine with Kurenkova in front of *Feast in the House of Simon the Pharisee* as they are quizzed by two sailors.

Kurenkova comments on the tranquillity and calm of Joseph, as well as God's unseen presence in this painting. As she explicates van Dyck, a young man clutching a book circles Custine and Kurenkova, staring at them in an obvious manner. Kurenkova explains the symbolism of the apple tree as representing life and the sunflower as a symbol of piety; this demonstrates a lack of spiritual education (as is typical for the Soviet era), as she ignores the biblical references. In Kurenkova's reading, the dancing and playing angels are a sign of worldly entertainment. The Narrator tells Custine to leave this 'angel' alone. Curiously, Kurenkova (and Khmel'nitskii and Eliseev earlier) explicate the paintings in a manner perceived as deeply spiritual by the Narrator, but without reading the biblical and religious references (a result of their atheist upbringing in the Soviet state). Meanwhile, the camera focuses on the child held by Mary. The sound of birds enhances the tranquillity of the scene, adding yet another worldly layer onto a profoundly religious painting. The film-maker's camera thus tells a different story than that verbalized by the invisible Narrator: the secular is juxtaposed with a religious and spiritual discourse. As piano music sets in, the camera zooms in and immerses the viewer completely into the painting, without showing the frame. Custine thanks Kurenkova for her valuable comments, but his intonation is somewhat cynical, as though challenging the notion that a blind person can really see more than the sighted. The men in black suits follow Custine and rush about the rooms, while one of them observes Custine closely, visually echoing Custine's sensation in the *Letters* of constant supervision and vigilance. Indeed, these men seem to be compiling an inventory.

Kurenkova suggests looking at another painting; she has now become the guide and leads Custine into the next room. But here Custine misleads the blind woman by claiming that Rubens' *Feast in the House of Simon the Pharisee* is not in the Rubens Room and has never been part of the Hermitage. However, Kurenkova is certain that it came to the museum from the Walpole collection, as did *Madonna with Partridges*. Custine locates the quite large canvas on the wall and comments on the painting's nice scent of oil. A few steps on, Custine admits that he is wrong, but now places Kurenkova with her back to the painting, despite suggesting that it is now in front of her. Kurenkova did not expect this move and was genuinely confused during the shoot. The Narrator suggests that although Custine knows the historical facts and he can see, this does not grant him the kind of insight into European art of which Russians are capable. Custine pays no attention to the opposition between Simon's dogmatism and that of Christian benevolence in the Rubens painting, and avoids the connection between the theme of the painting and his own situation, misleading an angelic person through his arrogance. Kurenkova's face lights up as she tells the story of Christ's benevolent act of blessing the female sinner, indicating the blind person's deeper understanding of the painting's spiritual meaning. Custine's harsh words attract the comments of two sailors passing through the hall; they come from a different age and time, most likely from the revolutionary era. The sailors aggressively address Custine in the second person singular – the personal form ['A znaesh' ty…'] – and tell him that the paintings were hung much more densely in the past. Custine confirms that the tsar would inspect the collection every day and made a special effort to keep it safe during the fire. The sailors are not sure when that fire happened; it is not part of their (Soviet) history, where the tsar would be accused of not giving enough space for art rather than being credited with his rescue efforts of the collection during the fire. Kurenkova takes leave and the sailors withdraw. Custine, too, is asked to leave the room by the men in black suits and white gloves, who claim that the museum is now closing. After the doors are shut, one of the guards opens them again to stick out his face, and exhales into Custine's face as if to blow him away. Custine responds with the same gesture before the heavy oak doors creak and close behind him.

Custine passes through another room as piano music begins to play. He pauses at Frans Mieris' *Lady at her Toilet*, for the first time discerning the details of the painting and uttering his boredom with the themes of 'rags, dogs and eternal people'. However, his comment may also reflect the fact that, by being painted, these people have become immortalized, and therefore echoes some envy on the part of the viewer: 'by crossing the painting frame immortality can be found' (Harte 2005: 55).

The camera pauses, focusing on the Spy's hands as he puts on his white gloves, possibly a trick to allow actors to move along. Custine asks what the Spy is doing eavesdropping on him; the Spy follows and sits down in the next room. In the Cabinet of Spanish Painting, Custine finds the 'Talented Boy' scrutinizing *Peter and Paul*, El Greco's painting of the Apostles. He quizzes the boy about the scriptures and their significance for the painting. Custine kneels down before the canvas and asks the boy whether he is Catholic, since he seems absorbed by the image of the church's founders. However, the boy has never read the scriptures. Custine alludes to the superiority of the Roman Church over the Orthodox one, and suggests that a lack of religious education in the Russian people makes it impossible for the boy to truly understand and appreciate the painting. Custine physically drives the boy into a corner. The boy explains the appearance of the Apostles, especially their hands, and says that one day all people will be like that. The film-maker apparently associates the boy's comment with the earlier focus on the Spy's hands: the gesture of the Apostles reflects their characters, one holding the key while the other keeps the Bible open, so that for a moment we are absorbed visually by the painting. As Custine scolds the boy for just seeing two dusty old men, the boy suggests that they have come a long way to be in this painting. According to Custine, the boy obviously cannot understand its spiritual significance without the gospels, but can only appreciate the aesthetic object (cf. Kachurin and Zitser 2006). The Narrator intervenes and scolds Custine for his aggression towards the boy, who in turn suggests that Custine should not be afraid of anything. The camera focuses on Custine and the boy, then on the Apostles. Custine's gaze captures the corner of an adjacent canvas and comments on the exposure of flesh (taking the cue from the Apostle's exposed hand). In a meek and vague tone, the Narrator hustles Custine away. Peter and Paul are, of course, also 'the patron saints of both Peter the Great and his city'; moreover, 'Peter the Great is the "rock" on which the city, the building of the Hermitage, and also the film is based, but a rock that weighs heavily around the necks of any Russian nationalist' (Kachurin and Zitser 2006).

As he moves on, Custine again comments on the fresh smell of the oil paintings, suggesting they are more 'alive' than he himself is, a formaldehyde-impregnated corpse moving through time. Custine refers to the tsar's gallery and the portrait of a medieval fanatic (Ivan the Terrible). He has enjoyed the music and wonders whether Glinka was a German, adhering to his arrogant perception that good music must be German: 'All composers are German', he says. Custine's arrogance – rather than ignorance – is stressed here. He has a great factual knowledge and functions like the keeper of an inventory (indeed, the function of a museum), but he cannot make connections between things; he looks at surfaces but, with very few exceptions, fails to see the stories in the paintings.

Imitating a lion's roar, which serves 'to accentuate the passage from one hall into another' (Harte 2005: 47), Custine opens the door to the next hall, the Rembrandt Room. The first portrait which the camera glimpses in passing resembles Rembrandt, and Custine believes the paintings are now getting better and better. The Narrator is content to see Custine impressed by the artworks. Custine stops before *Abraham and the Three Angels*, but turns to the side as the camera pans over the painting. In it, Abraham is cutting a fowl and Custine comments that again there

Figure 11: Custine corners the boy in front of El Greco's *Peter and Paul*.

Figure 12: Custine and Alla Osipenko in front of *Danaë*.

is flesh (meat) here, while the Narrator whispers to him about the angel. The divide between perceiving the material and the spiritual aspects in paintings could not be more distinct than in this brief exchange.

The camera turns around and reverses to a corner, where Custine finds a woman talking to Rembrandt's *Danaë*. Custine approaches her without having been introduced. This is Alla Osipenko, who tells him voluntarily that she likes to speak with the canvas and feels elevated by this conversation, so much so that she proceeds to dance through the room. Custine engages with the dancelike movements of her arms for a moment, as music accompanies the scene. Osipenko leaves and Custine follows her, worried that he has offended her. Osipenko returns with a nun dressed in white (who will later make an appearance in the Nicholas II scene). Sokurov seems to suggest once again that Russians relate to paintings in an emotional and almost physical way, whereby speech and touch form part of the contact with the paintings.

Custine strolls through the Rembrandt Room, viewing its exhibits. The camera focuses on *Timothy and Lois*, zooming in on the boy's face; Custine offers no comment on the purely spiritual theme of holy mothers. He is already before another painting when a group of Red Army soldiers pace through the room and the sound of a plane can be heard: the time of World War II is anticipated here, to be seen fully in the following room. For the moment, Custine scrutinizes *Return of the Prodigal Son*, and the camera zooms in but never loses sight of the frame. The painting remains an object, and once again Custine has no comment on the theme of redemption through repentance – moral and spiritual concepts that appear alien to him.

Custine scratches his head and rubs his feet against each other. He stands on wooden floorboards and ornamented parquet; he moves on and the floor changes to white marble: the transgression of spaces, i.e. the move into another part of the building, is this time signalled by the camera focusing on the floor. Custine leaves the exhibition rooms and finds himself on the Council Staircase. He converses with the Narrator about the destruction that Custine must have seen here during his visit that followed the fire. Goncharova and Pushkin are seen again, chasing each other and arguing on the landing.

THE STAGE OF HISTORY

Custine compares the fire's destruction to the French National Convention (1792–95), an assembly elected by male suffrage. For Custine, this form of government diluted the power of the monarchy by empowering the people. The Narrator comments that Custine does not know the history of the twentieth century, which had its own Convention that lasted for 80 years; it was a very sad event, a real revolution. Custine enquires about the current system of Russian governance, but the Narrator is not sure what to say – another indication of his uncertainty. Custine never liked the republic as a form of government and considers it unsuitable for such a large country as Russia. The Narrator contradicts him by suggesting that Europeans are democrats who mourn the monarchy. He wonders whether his interlocutor (still unidentified by the Narrator, although referred to as 'Marquis' by Khmel'nitskii and Eliseev) is French. Two guards approach and quiz Custine, who has lost his sense of direction. The guards tell him that access is forbidden and Custine argues with them, claiming (as he does in his *Letters*) that everything is forbidden in the country and nothing is allowed. The Narrator advises Custine not to argue but to leave, once again withdrawing into his role as a meek and humble visitor, rather than a challenging and inquisitive visitor.

Custine withdraws into a side corridor and opens a beautiful door that the Narrator tries to stop him from opening. He enters the gallery to the eastern side of the Small Hermitage, which is filled with empty, frost-covered and cobwebbed frames: it represents the Hermitage during the Siege, when the actual paintings were evacuated to the Urals. There is a carpenter in the gallery who is making his own coffin and chases Custine out of the room. Custine knows nothing of the catastrophes of twentieth-century Russian history, and the Narrator makes little attempt to tell him. He mentions the war with Germany (Custine claims that he does not even

know that designation, even though the German Confederation was established at the Congress of Vienna that he attended), and that the city did not surrender when the Germans army surrounded it, and that more than a million people died during the city's defence. Custine says this is a high price to pay, while Sokurov counters with a Russian saying: that freedom has no price. And whatever the price may have been, it has already been paid: history is irreversible. More important here is the reference to the price of human lives paid not only for the defence of the nation, but also for the protection of the museum's European cultural heritage. This is a point to which Sokurov would return in his film *Francofonia*, about another major European museum, the Louvre.

While this threshold between the two buildings combines the historical with the artistic journey, from here on Custine returns to the strictly historical part of his journey that he began in the apartments of Peter the Great and the leisure space of Catherine the Great. Custine admits that he was wrong to criticize the tsars for their concern with beauty and opulence; in the scenes where history is re-enacted, he enjoys himself and feels 'at home'.

A servant wearing a wig passes with a cup of tea, signalling we are now in the eighteenth century. In the Pavilion Hall, Custine hears the sound of music in the distance and the voices of children. He sees an aged Catherine II leaning against a column with her tea. Then the children, who have been playing blind man's bluff, approach her. The Narrator comments on her sixth sense, and warns Custine to stay at a distance so that he is not noticed. A grandee instructs the children to bow before the empress and they do so. Catherine feels stuffy inside with all the candles burning, and is in need of fresh air – certainly a metaphorical comment. Supported by a walking stick and the grandee, she approaches the door to the Hanging Garden of the Small Hermitage, which her grandee opens for her. She steps outside into the snow. The camera follows her as the grandee helps her hurtle along, faster and faster, into the distance. Custine shouts for the Narrator while the camera follows the empress. Custine follows at a distance, warning that one should not get too close when following mortals, and he hears the Narrator's footsteps behind him. As he feels cold, he turns to the right, into an entrance to the building.

After his visit to the museum collection, Custine returns to life at the court and enters the building of the Winter Palace proper, with the Narrator following. Custine remarks that, once again, Catherine has disappeared (as in the previous scene): she is like a ghost and her appearance is truly spectral. Again, a guard tries to bar the Narrator and Custine from entering, but they are eventually allowed in. In the hall, preparations are under way for a masked ball, and we meet again with the small crowd of people, some wearing Venetian masks, who appeared at the film's beginning. These masked actors are fascinated by Custine's hair and offer him a cup of tea. Custine sits down for a moment at a table, but refuses to tell them a story. They show Custine a book, but Custine denies that this is his writing; he alleges it is the Narrator's, which led Ulrich Schmid (2003) to suggest that Narrator here tries to exorcise the critical European Other inside him. Custine cannot see what the next room holds and peeks through the door

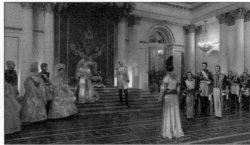

Figure 13: Custine and the carpenter in the room with the coffin and empty frames (representing the Siege).

Figure 14: Nicholas I receives the Persian envoy's apology.

before proceeding. He tells the Narrator to close the door behind them, now himself making sure that he seals the historical episodes one after another.

The Narrator and Custine find themselves in St George Hall, where Tsar Nicholas I receives the Persian emissaries as they apologise for the murder of Russian diplomats, including the Russian poet Aleksandr Griboedov. Custine comments that he never saw this hall in its full glory as it had been badly damaged by the fire. Now even the parquet does not creak. The ceremony reflects the meeting of two cultures: the officers stand in line at both sides of the hall, while the Persian emissary, Prince Khosrow Mirza, grandson of the Shah, is announced. Custine keeps on apologizing as he passes along the hall behind the officers, explaining to the Narrator what is going on (i.e. an apology for the murder of Russian diplomats). As Custine advances, he warns the Narrator to be careful not to be noticed. Custine goes off to see whether he can find some of his acquaintances. The camera pauses before the Persian delegation, facing it from the perspective of the throne, before moving behind it and following the emissary as he approaches the tsar, who stands on the steps to the throne, with the empress to the right. The emissary recites his apology in Persian, which is then translated. The camera pans out and retreats, turning away from the tsar and focusing on Khosrow Mirza's entourage. After the apology has been read out, the camera returns to the tsar, who has his reply read out, rather than pronouncing it himself – a sign of the pain caused by the murder of the Russian diplomats. The camera retreats while the acceptance of the apology fades into the background. It turns toward a forward motion, covering the faces of the officers in attendance and the curious gazes of the ladies. Then the camera catches up with Custine at the main door, where he is told that he has no business here and should leave. Custine claims that he had no intention of staying, since this ceremony will continue for several hours and will be followed by general boredom. As a former diplomat, he would know. Custine goes along a corridor, the camera now ahead of him, while he is followed by the Spy. He admires the architecture and splendour, and acknowledges that Stasov was not a bad architect after all.

In the Banquet Hall, Custine admires the Sèvres porcelain as the Narrator reminds him to move on before the ceremony ends and before the guests come into the room. This cameo service from 1777 was created by the Sèvres porcelain manufacturer in neoclassical design, with cameos embedded in the turquoise enamel that required several firings to achieve its intense colour. The 900-piece set had been a special commission from Catherine II and bore her insignia. As Custine is ushered out of the room, he remembers the taste of the food and indulges in reveries about the splendour of the palace during his visit, reflecting his ambiguity between admiration for the opulence and criticism of the administration of Russia in 1839. The sound of violins is audible from afar and Custine moves along.

Custine is alone in a dark hall, which has a window to the side that offers no view out and no light in. He (correctly) suspects that his interlocutor has never seen a tsar in his life. The Narrator confirms that monarchies do

Figure 15: Custine inspects the Sèvres porcelain.

Figure 16: Three consecutive directors of the Hermitage in the darkened Memorial Hall of Peter the Great.

not last forever. The Narrator hears voices that Custine cannot hear due to the fact they exist in different historical dimensions. In the Memorial Hall of Peter the Great, the camera finds three men: the former directors of the museum, Orbeli and the older Piotrovskii (played by actors), and the real-life Mikhail Piotrovskii. They discuss the conservation of Peter's throne, which is resistant to insects as it is made of silver and treated oak. However, Orbeli is worried about the cover made from *velours de Lyon*. They are running out of time to preserve the material, commenting directly on issues of preservation and restoration that have only been alluded to so far in Custine's comments. Orbeli encourages Boris Piotrovskii to tell his son what he has to say, but he fails to pass on his wisdom and knowledge before the young Piotrovskii is called away. The older men managed to steer the museum through wars and catastrophes. The elder Piotrovskii asks whether the phones are still tapped, but Mikhail would rather tell his father about the Hermitage cats. He says both Orbeli's and Piotrovskii's books are much appreciated and in demand. The contemporary Piotrovskii shares the past directors' worries about the authorities who want, in his words, 'acorns without oak trees', and who have no idea how to feed and nourish trees; in other words, culture is still the stepchild of Russian politics. Custine, relying on the Narrator to tell him the content of the conversation, believes that the men will not tell Mikhail anything, as people can see the future, but not the past. There is a light piano accompaniment to the scene, endowing it with a melancholic atmosphere.

In the next room, the military officers are undertaking a drill. Custine does not like the military. The Narrator confesses that he made up the directors' conversation and did not actually hear anything. Custine enters the next hall, clapping his hands and chasing some girls in the corner. Again, the camera follows Custine charging down a long, empty gallery – the Portrait Gallery of the Romanovs (the paintings have been removed), where Anastasia and her friends are playing. The girl is reminded by her mother, Alexandra, that she should join the family at the dinner table. Alexandra, dressed all in white and wearing a fur shawl, is accompanied by the 'white nun', her older sister, Grand Duchess Elizabeth, who was married to Grand Duke Sergei until his assassination by socialist revolutionaries in 1905. Following this tragedy, she founded a convent and became its abbess. Alexandra feels watched all the time; she tells Elizabeth that she has had a premonition and imagines that she has heard shots. Custine is out of the camera's focus as it tracks the two women, while a piano tune can be heard in the distance. The constant sense of being followed and watched – the spies, guards and cameras – is what Custine describes in his impressions, and it is here extended to the empress. Elizabeth tries to reassure Alexandra, who is also worried about Alexei's illness and his immobility; she has no confidence in the doctors, no hope for a cure and a sense of guilt that she passed on the disease. They enter a bright room, where Anastasia and her friends peek through the door into the Small Dining Room. There, Olga, Tatiana, Maria and Alexei are seated at the table; Anastasia then joins them whilst the tsar stands at the head of the table. Nicholas II is portrayed as a family man and a kind father, a portrayal that stands in sharp contrast to his historical role, but which reflects his martyrdom following the (controversial) canonization of the last

Figure 17: Nicholas II *en famille*.

Romanov family in 2000. The dining room is all in white, with a hue of red added through a filter in post-production that has been interpreted as the colour of the blood that would be spilled. Elizabeth leaves the room and chases away Anastasia's friends. The camera follows them out of the room and the antechamber, and through to the Malachite Room and the Concert Hall.

THE BALL

In the anteroom to the hall, voices can be heard discussing the number of guests expected at the event. The Spy wanders through the room and into the Great (Nicholas) Hall, where the ball is about to start. The Narrator has temporarily lost sight of his European guest. In a similar search movement, the camera pans around the hall and stops at various groups of guests before it locates Custine in conversation with a lady. Custine does not hear the Narrator and dances off on his own through the hall. The orchestra begins to play and guests dance to Glinka's *mazurka* (actually played at the 1913 ball in the Philharmonic). The camera slowly moves through the hall and approaches the Mariinsky Orchestra, conducted by Valerii Gergiev. The ball is not a costume ball, but the women are dressed in elegant gowns; some wear (European) feather headgear, while others don the (Russian) *kokoshnik*. We overhear some small talk about a general's dispatch to Africa. The camera circles the hall as the dance gets under way, imitating its circular dance movement. Custine and the Narrator are separated. We again encounter the officers from the film's start, one dancing with the lady in white. The camera pans over the orchestra from behind, with Gergiev in the centre. Custine claims that he has forgotten how to dance, but he soon remembers the movements. He calls the event one of the best balls in Europe, with over 3000 people in attendance. Again, the camera lingers on the orchestra and conductor as the *mazurka* ends. The orchestra takes its due applause, the camera pulls back onto the crowd, and the Narrator and Custine find each other. Custine asks the Narrator where the path leads from here, as they are about to exit the hall. 'Forward,' says the Narrator. Custine wonders what the future holds and what they will find there. He decides to stay – not so much in Russia, but in the past. The crowd leaves the hall, making their way around Custine and onto the richly ornamented Jordan Staircase, built to the grand design of Rastrelli. The Narrator bids farewell to Europe, commenting that 'it's all over'. Custine remains in the past, while the Narrator exits with the guests: one is a part of history, preserved in the museum; the other is a temporary guest in the glorious past. The Narrator knows what the future holds: a cultural wasteland.

The camera follows the crowd and overhears snippets of conversations, exiting via the Jordan Staircase. At the top of the stairs, we again encounter some ladies in Venetian masks and an actor in a red gown, who appears to be from the play performed in the Hermitage Theatre at the film's start. The circle of the journey into history closes here. We also close the second circle, rejoining the ladies once again and two of the officers who arrived at

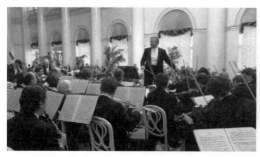

Figure 18: Gergiev conducting the
Mariinsky Orchestra.

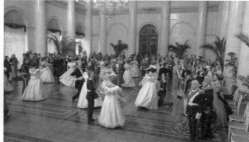

Figure 19: The great ball in
Nicholas Hall.

Figures 20 & 21: The guests descend
the Jordan Staircase.

the film's start, who now stop at the top of the staircase. They decide to dine at The Bear and must have their coats brought up. A stout lady in purple (from Kursk) is satisfied with the ball and suggests to her husband that they must organize a ball for Lent festivities [*maslenitsa*] when they return home. The camera captures their descent both from behind and from the front, which is possible since the staircase has two wings; it looks both upward and downward. The comparison with Eisenstein's *October* (1927) is obvious: that film's final scene is set on the same staircase and features the ascent of armed soldiers seizing the palace. In *Russian Ark*, the guests close the gap left by the passing camera as it swiftly pulls back, leaving the gallery and disappearing into a grey semi-lit space, where it finds an open door. The Narrator regrets that Custine is no longer with him. The camera leaves through the door and opens the view into a murky (CGI) image of a river veiled in fog and dark clouds. 'We are destined to sail forever, to live forever,' pronounces the Narrator to the sound of waves and some low-key piano accompaniment.

Chapter 4
<u>Themes and motifs</u>

It's a film in one breath, like inhale and exhale.

(Sokurov in Ivanov 2002)

Sokurov titled his film *Russian Ark*. One may decide that the emphasis is on 'Ark', as in Noah's Ark, a vessel that was built to rescue the animals (in pairs) from the deluge so that they can propagate on the other side of the catastrophe, whatever that catastrophe may be: the flood of St Petersburg described in Pushkin's 'Bronze Horseman' – nature's revenge on Peter the Great for having dared to challenge the elements by erecting the city on swamps and bogs; or the historical deluge of the October Revolution that swept away the Russian empire to make room for the socialist state. Yet we may agree with Pamela Kachurin and Ernest A. Zitser (2006) who have commented that 'it is a *Russian* ark (the Hermitage) that remains afloat on the waters of time to carry on the mission of restoring Culture to a world chastised by the wrath of God' (emphasis in the original). In this reading (which we shall explore further in Chapter 5), the emphasis is on 'Russian': it involves a narrative concerned not with protection, but with Russia's mission to save European traditions and heritage rather than its own culture. In turn, this mission has repercussions on the way in which we can inscribe Sokurov's nationalist views into this film. And one does not have to look as far as its critical reception to find a confirmation of such a position, but to Sokurov himself, who confirms that 'this is a Russian, national film' (in Ivanov 2002). One may also look at the production history, which united Germany's and Russia's cultures: 'The ark with its precious cargo, adrift under conditions of early twentieth-century catastrophe, is reunited with Europe through the fact of the film's production' (Condee 2009: 178). In a more polemical narrative, Dmitrii Komm has read Sokurov's nationalist view and compared it to Nikita Mikhalkov – a comparison I have entertained elsewhere (Beumers 2003) and which is echoed, albeit modified, by Yana Hashamova (2006): 'Sokurov did what Nikita Mikhalkov did not manage in "The Barber of Siberia". Without a 45 million budget and enormous crowd scenes, he fulfilled the state's commission for a view of Russian culture as a continuous traditions' (Komm 2003).

Sokurov may support Putin's policies and share his desire to restore Russia's grandeur, but the position mooted here is one of a profound belief in Russia's role as a missionary of European culture, perhaps even its saviour – with all the political incorrectness, Slavophile inspiration and clichéd repetition of Russian spirituality that this involves. What is terrifying is the consistency of this position when we look beyond the ark at the sinking ship in *Francofonia* (2015), to which we shall return in the conclusion.

This chapter discusses some key themes and motifs of *Russian Ark* and – like Noah's attempt to load animals in pairs – is organized along binaries as they present themselves in the film, running in two parallel and interlocked yet

separate lines of movement that end in death – both physical (for Custine, who remains in the past) and spiritual (for Sokurov, who leaves the ark):

> Sokurov's cinematic ark [...] is hardly an inclusive congeries of all earthly animals, two by two. Instead, it is a gathering of imperial gentility adrift in a social catastrophe largely of its own making, dancing to the exquisite music of its isolated culture, oblivious to the impending historical accident that is in fact its own inevitable death.
>
> (Condee 2009: 160)

The organization of the chapter thus tries to capture some of the binaries, contradictions and duplicities inherent in the film's structure. After all, a single breath consists of two movements: inhaling and exhaling.

HERMIT VS. CROWD

One of the first binaries lies in the (contradictory, paradoxical) juxtaposition of two lonely individuals, two hermits in the Hermitage who move among and against crowds. At the same time, it is possible to read the two individuals as different sides of the same thing: 'the mutually contradictory opinions of Custine and Sokurov are actually two sides of the same coin' (Kachurin and Zitser 2006). Custine and the Narrator represent Europe and Asia, but at the same time the Narrator adopts the lens of a European eye, aligning himself and Russia as an intrinsic part of Europe. In this sense, the Narrator voices his concerns about Europe's perception of Russia through Custine, and paradoxically tries to justify Russia's course by not contradicting him, but rather by making him his ally. Whilst several critics (Halligan 2003; Schmid 2003) have noted external similarities between Custine and Nosferatu (for instance, the long fingers, the black tailcoat), Schmid (2003) has gone further by suggesting that 'Custine represents a demonic force within the narrator's own soul. [...] Sokurov performs a kind of exorcism: The anaemic French diplomat who sucks the blood from the vital body of Russia must be overcome'. Whilst the image of a vampire visiting Russia to suck its blood (indeed, what blood?) may be a little exaggerated, there is another quite pertinent aspect in this metaphor, namely that of the double. Custine, then, functions as an alter ego for the Narrator to un-voice his comments, as it were: to have Custine speak and expose his narrative in the guise of an arrogant and disdainful European unable to appreciate Russia's sacrificial and missionary role, and to have Russia's humble and subservient role confirmed in the Narrator's discourse that leaves most statements without contradiction and places Russia into its classical and traditional role of victim, martyr, saint.

Indeed, Custine was somewhat isolated in St Petersburg during his visit in 1839. He had a lot of recommendations and met a lot of people, but he was largely on his own, alone and lonely. This is particularly evident in his description of his attendance at the wedding of the Grand Duchess Marie and the subsequent reception at the imperial palace, without his proper range of suits and having lost a shoe along the way. In his *Letters*, he bemoans that this 'hermitage' is not at all a place of isolation, but a hub: 'The Hermitage! Is not this a name strangely applied to the villa of a sovereign, placed in the middle of the capital, close to the palace where he resides! A bridge thrown across a street leads from one residence to the other' (Muhlstein 2002: 349–50).

On the other hand, José Alaniz (2011) has written about crowds and crowd control in the film, where some 1000 people had to be instructed, steered and moved across the Hermitage without being reflected in the numerous windows and mirrors, and without getting in the way of the camera crew. If we look carefully at the scene in the Raphael Loggias, the camera actually shies away from the mirrors, but there are numerous 'film flubs' that Alaniz lists in detail and covers in depth. The crowd descending the Jordan Staircase after the ball is a disciplined, national, united crowd, not a diverse and motley bunch of people. Contrast this with the people of Odessa – old and young, well-dressed and shabbily dressed, educated and not, healthy and disabled – who 'bounce' down the Odessa Steps in the famous scene of Sergei Eisenstein's *Battleship Potemkin*. As Alaniz (2011: 169) concludes, '*Russian Ark*'s culminating staircase scene (with

its hundreds of cast members in pre-revolutionary dress languidly descending the steps) incarnates Sokurov's most overt evocation of *sobornost'*, allying his beloved European high culture with traditional Russian religious-nationalist sentiment'. Alaniz compares the final scene of the descent on the Jordan Staircase to a 'mobile version' of the work of Slavophile painter Il'ia Glazunov's *Eternal Russia* (1988), which marked the millennium of the introduction of Christianity to ancient Rus'. This work shows a crowd of Russian martyrs, saints and historical figures walking in a procession around a Christ-figure in the centre, with a Kremlin in the background of an entirely flat painting that lacks depth or perspective, as is characteristic of religious medieval depictions. The crowd in *Russian Ark* is also juxtaposed in its disciplined and organized movement to Eisenstein's chaotic crowd of armed men storming the Winter Palace and racing up the Jordan Staircase in *October*. The scenes of the intrusion into and usurpation of the space then cut to the men inspecting the furniture in the imperial apartments (especially the various urinals), before looting begins and is stopped. There is a short scene in the dining room (the scene in *Russian Ark* with Nicholas II is set in the same room) before the largely female captives are led down the staircase by the armed men. The movement is staccato, with one action intercut into another; it is movement of in and out, of taking hold of and control over the people in the palace. The staircase functions in both directions, first for the entrance of the 'new people', representing the usurpation of the palace, and then the exit of the old order, leaving by force. No such force is applied in Sokurov's film, where the bourgeoisie and aristocracy leave the Winter Palace of their own accord, never to return there:

> Treating them [the ball-goers] as pitiful victims, or what is worse, as martyrs in a nostalgic and sentimentalized vision that exists only in the partisan interpretations of nationalist mythmakers, deprives the real historical figures depicted in the movie of the agency that they most surely possessed.
>
> (Kachurin and Zitser 2006)

The movement of the two hermits against this disciplined crowd in *Russian Ark* is synchronous insofar as one hermit is invisible, while the other is steered through the 33 rooms by events, pushed from one space and drawn by another, led by passages and doors that open and close for him. Nancy Condee (2009: 176) has rightly suggested a possible comparison to the navigation of a computer game: 'Its effete cast retains a lifeless, wax museum quality; they are avatars in a retro video game navigating corridors and hallways, encountering historical figures but, more importantly, viewing priceless art'.

FRAMES AND DOORS VS. THRESHOLDS AND CORRIDORS

Doors, frames, thresholds and corridors seem to organize the movement in *Russian Ark* without any previous planning (which is, of course, contrary to the accurate maps drawn by Sokurov for the filming). It seems as if Custine walks through the Hermitage and is guided by chance: doors open for him or close behind him. He is drawn or attracted by people in the museum yet avoids crowds; furthermore, he tries not to be noticed by the guards and avoids the Spy (played by Leonid Mozgovoi) who follows him throughout. The creaking doors and squeaky hinges emphasize the importance of doors, but even more so do Custine's gesturing and his mannerisms. When opening a door and entering a new room, he often raises his arms as if to embrace the new space in a jubilant manner; when exiting a room, he often spouts air and exhales – a gesture repeated by one of the guards later in the film. In his succinct and perceptive analysis of the use of doors and frames, Tim Harte (2005: 44) has suggested that 'a succession of frames – doorframes, picture frames, and the constant film frame – guide [the camera's] movement'.

Above all, there is the entrance to the Hermitage itself. A group of officers and ladies, along with Custine and the Narrator, pass a set of barriers and a gatehouse before using a side entrance that takes them first downstairs and then upstairs, passing along a suite of rooms in the basement, then entering the theatre from the backstage and exiting via the foyer, i.e. back to front. Thus, the entrance to the museum is actually a backward movement, as it were.

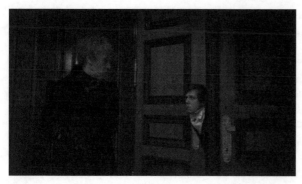

Figure 22: The guard spouts air and
Custine repeats the gesture as he exits
a room.

Subsequently (and not surprisingly), Custine is lost in space: he does not know which country he is in (he speaks Russian, so it must be Russia), or which city, or which building. He follows the small crowd until he gets inside the theatre; then he goes after Empress Catherine, who disappears in a small vestibule adjacent to the theatre foyer, which has several exit doors, one set of doors is opened for Custine, as if he had been awaited in the gallery.

Each time Custine enters or leaves a room, the camera captures the doors, the handles or the door frames. The intruder Custine penetrates space and moves from one self-contained space into another, and from one epoch into another. Indeed, the rooms are sealed before and after, merely allowing for a temporary passage by Custine. He enters different spaces, and within each space there are different conditions for his existence: sometimes he is out of synch with time (in the museum space, for example, where he can smell the formaldehyde emanating from himself as a relic of another time); sometimes he coincides with time, as in the historical scenes, where he is noticed by others (especially the guards) during the reception of Nicholas I – not an event that he attended, but one that falls within his lifetime. Like a ghost, Custine is capable of crossing thresholds of temporal and spatial limitation; as a spectre from the past, he can move freely across time:

> In a broader, metaphysical sense, the frame signifies an active transition into a new, unfamiliar realm of experience. Hence frames, be they doorframes, window frames, or picture frames, denote a threshold over which the viewer or traveler must cross to reach what is on the opposite side of the frame. For the work of art, the threshold of the frame encourages the viewer to enter into a separate aesthetic sphere.
>
> (Harte 2005: 46)

There are few close-ups of paintings where the picture frame is eliminated from the camera's frame (for example, the Tintoretto, the *Prodigal Son* and El Greco's *Peter and Paul*), and only in some paintings are we allowed direct access to the world behind the canvas, beyond the surface. The framing device of paintings and enacted events 'reproduces history, but as a unique event, an archivization that wavers between a "live" gaze at history and a museified iterability, its return as a "dead," self-enclosed and spectralized spectacle' (Kujundzic 2003). Kujundzic here explains two motifs of Sokurov's work: firstly, the way in which the flat, two-dimensional frame – picture frames and stage arches – creates a seemingly live viewing of history that is in fact dead; and secondly, the correlation between archivization, preservation and restoration (in the physical sense and also in the sense of restoring the past), and the nostalgic, melancholic and elegiac mode for past times and the spectral characters that once inhabited that past.

FRAMES OF REPRESENTATION AND RE-ENACTMENT: IMAGE AND PERFORMANCE

Sokurov's interest in museums has already been noted, as well as his training as a historian. In *Russian Ark*, he chooses the site of the museum as filming location and identifies the museum as the ark that carries Russia's cultural heritage. However, it is in fact that of European civilisation at large sailing under a Russian flag (if you allow me that metaphor). Indeed, when talking of the 'single breath', we should not forget that breathing involves two components: inhaling and exhaling. It would appear that Sokurov's film is divided along those lines: the inhalation of the art objects represented in the museum and the absorption of the themes depicted followed by an exhalation in the second part of the journey that involves moving among stages of historical re-enactment. Such a division of the 'single breath' into two phases makes sense in the context of the different disposition of Custine in the museum (where he bemoans Russia's imitation and antagonises the people he meets, all from different epochs), and the animated and admiring Custine in the reception and balls scenes (where he is an agent).

There are two objects with entirely different qualities that the film 'frames'. The first is the re-enactment of historical scenes, which we observe but which we must not disrupt: the Narrator tells Custine not to go into the room of the Siege (the Narrator's past, Custine's future), and Custine himself refrains from intervening in the actions of Peter the Great (his own past). However, the re-enactment of the past is not enough. There is also a meta-layer of performance which includes the play staged by Catherine the Great, but equally the ritual, rehearsed feel of the court ceremony of the Persian ambassador's apology, or the masked group of people that serves as a framing device and appears at the beginning and end, as well as the moment of transition from museum to history. In this historical enactment, neither the Narrator nor Custine has a role to play: history is a written thing, subject to repetition and restaging, but not to modification, and we – the spectator, the people – are disempowered. In Sokurov's view, man has no role in history; he is not a producer of history, but a victim.

Secondly, there are the paintings: they also depict history, but of a more distant past, and cover both secular and religious subjects. The depiction in the paintings is static, and therefore not subject to change, but open to interpretation. At the same time, painting as an art form competes with the art of cinema (a theme to which we shall return), and where frames play an important role. Here, the juxtaposition lies between the live and mobile enactment of history versus the static and frozen image of a scene. Both images exclude participation, but offer a glimpse into other times: one glimpse where time unfolds, and another where time is static. The static image creates immortality (as Custine suggests when looking at Mieris' painting and when commenting on the 'eternal' people), while the re-enactment is in flux – it lasts for a brief moment in time, unfolding along with our time. In other words, the camera time runs parallel to the re-enacted historical scenes, while it elapses and seeps away against the time encapsulated on canvas that will stay there forever – or at least as long as the ship sails and the ark is intact. Time is thus an important factor in our consideration, and here we return once again to the single take and its importance.

STILL AND MOVING IMAGES

I want to explore further the motivation for using the long take to cross borders of space and time by examining the artistic images viewed and the scenes enacted on the historical journey within the space of the museum in order to define Sokurov's view of the art of cinema, less so in respect of its place in the hierarchy of art forms than in his use of the camera to capture images – still and moving, on canvas and live action. We have already noted the importance of frames and thresholds that delimit the ephemeral from the eternal, and that place *Russian Ark* firmly into the thematic scope of Sokurov's preoccupation with morbidity and death (Harte 2005), but we should add to this consideration the entrapment of history within a museum space and his use of the elegiac form (Jameson 2006). However, in light of the film's (and film-maker's) concern with the Hermitage's space, which is used both to gaze at the museum's art objects and to re-enact historical events in the former imperial palace, the film oscillates between

a representation of history through performance as well as through visual art. The camera captures both theatrical enactments (in motion) and paintings (fixed images), (self-)reflecting on the optical and technical device that records both movement and stasis, and which plays the role of director-choreographer and painter, here a predecessor of the still photographer. The oscillation between fixed and moving images is further intensified by two discursive lines: first, the Narrator, who has no face and no memory of the past, but who seems to know the future and Russia's destiny; and second, the Stranger, who remembers a past that becomes the present through enactment, but who has no knowledge of the future and remains inside the museum space at the end of his journey. In this context, the rejection of filmic cuts in order to create the illusion of temporal flow leads to another kind of montage that juxtaposes the content in the frame (the canvas) with the theatre performances in the architectural space, synthesized, as it were, by the film camera. Sokurov assembles two parallel discourses – of representation and performance, breaking the chronology of the enacted scenes through the histories told on canvas, within the (pictorial) frame. The frame (of the painting) is as selective as the lens of the camera which singles out scenes, tilts and turns as it follows the gaze of the Stranger:

> In making these marked borders so conspicuous, Sokurov begins to underscore the critical link between his celluloid images and the medium of painting, which both depend on the frame for visual and presentational purposes. Picture frames enclose painted images, demarcating their status as timeless works of art, while within the institution of the museum, the frame, in addition to enabling the installation and display of paintings, directs the human gaze, helping the observer to focus on and explore a given image. Meanwhile, for the medium of film the frame is even more of a constant (albeit a less obvious one), for every individual image on a strip of film constitutes an individual frame.

> (Harte 2005: 46)

For Sokurov, the camera is a tool to elevate cinematic art not to create and remake the past, but to erase it. Between the painted and performed scenes lie the 'real stories', the gaps that are blanked out. Dragan Kujundzic (2004: 227) has spoken of the 'vigilant erasure of the entire Soviet period', but I would go further than that: Sokurov's long take of the Hermitage's galleries, loggias, gardens, halls and staircases is a funeral procession, leading to the burial of the once glorious past in the murky waters of the Neva. What remains are the paintings, which are but a pale reflection of that which is no longer, and which therefore cannot be captured on celluloid (or rather HD). Sokurov rejects film as a medium to capture, record or (re-)create history: images are only façades (performative and framed), with

Figures 23 & 24: The camera leaves through the Hermitage's door onto the Neva.

the camera wavering between stage and frame. In this reading, the excursion into the room with the empty frames (of paintings evacuated during the Siege) draws attention to the (relative) absence of visual records of this time, intensified in the juxtaposition between static images and the acoustic/aural 'animation' of the Siege memoirs in Sokurov's documentary *Chitaem blokadnuiu knigu/We Read the Book of the Blockade* (2009). Sokurov may rank visual art over cinema; he may assert that art captures the eternal while the camera's lens sees the transient; however, his camera creates the ultimate content (the void) at the film's end: 'Sokurov's one shot, although it must end, is implicitly eternal in that no cuts, save for the beginning and the end, occur; it is as close as cinema can come to capturing, at least visually and viscerally, the eternal essence of culture' (Harte 2005: 58). It is no accident that tactile movement (the Spy's hands in close-up, Custine's own long fingers and Kurenkova's touch) fascinates the film-maker, and creates a link between observer and painting that is not exclusively visual.

The final (and only digitally created) image of the film leads from the ark to the sea, or the Neva – a murky, foggy, grey patch of marshland that rises outside the entrance to the Hermitage:

> Pondering the imperial capital's tenuous relation with the sea, the marquis had a vision of flooded St Petersburg sinking back into marshland. The digital fog that rolls around the Hermitage ghost ship shrouds Sokurov's ambiguous declaration: 'We are destined to sail forever, to love forever.'
>
> (Hoberman 2002)

Sokurov's obsession with aesthetics, with the photographic and poetic composition of frames, and the filming of paintings to capture both content and texture – for example, in *Hubert Robert* (cf. Iampolski 1999) – is what matters also for *Russian Ark*. The film loads content – however European and unoriginal – into the space of the Hermitage. Yet this content belongs to the past, and is resuscitated through the gaze (the paintings), the touch (the artwork), the smell (oil paint) and movement (the enacted historical events). It is buried again when the doors close behind the camera, suggesting a melancholy for a past that is never to return. Russia had its glory in the past, but that past is dead, 'preserved' only in the museum, while the present is void, empty, non-existent. The present is an empty frame that signals the helplessness of the film-maker before the secondariness of cinema, which is something Sokurov has talked about at length (Condee 2009: 180–183). The architect may create spaces (historical); the painter may capture the essence of life (beauty, grace, benevolence, redemption, faith) on canvas; actors may perform historical events – they each bring to life what is dead. Yet Sokurov's camera can do nothing but capture these primary art forms. When history's doors close for the last time, the frame remains empty and dull, tinted in a colour scheme typical of the morbidity of Sokurov's films.

Indeed, this is Sokurov's own empty frame, in which the images of the past can be rehung and reinstated, returned to the frames from which they were removed during the war. Sokurov's camera never captures reality; here it focuses on surfaces and performances in a hermetically sealed space, drawing attention to the camera as a 'framing' device. Sokurov needed that long take to disallow the editor from juxtaposing points of view: 'Sokurov's movies fill the represented world with absence and interiorize this absence with obsessive archivization' (Kujundzic 2003).

PRESERVATION VS. RESTORATION

The space occupied by the paintings does not intersect with the historical time of their acquisition. The Hermitage is an enclosed space, containing past and present, preserving the past for the future. It is the preservation of the past which interests both the Hermitage museum and the film-maker Sokurov. However, for this reading of Sokurov's film we should differentiate between preservation or conservation (that is, safeguarding cultural heritage) and restoration, which suggests the intervention of modern technologies into the resurrection of objects that have perished. St Petersburg's first museum, the Kunstkamera, engaged in the preservation of life forms by halting decomposition.

However, the process of preservation destroys the body that it aims to preserve, making its 'death' irreversible: the skin of animals or flowers immersed in spirit or toxic formaldehyde decomposes when removed from the liquid; they lose their identity in order to be preserved (and one might draw a comparison to the immortalized and perfected artistic image that requires the living copy to perish in Oscar Wilde's *The Picture of Dorian Grey* [1890]). This is the link between living and dead objects in archives and museums – the archive and the museum are necessary when memory fails, as they are a measure of preservation, and only partly of restoration. Indeed, the story of the Danaë painting and its inclusion in the film is interesting, since the painting – part of European heritage – has been restored and is preserved in Russia, so Sokurov indirectly questions the nature of its belonging.

Indeed, embalming and preserving are ways of creating, as André Bazin suggested: 'If the plastic arts were put under psychoanalysis, the practice of embalming the dead might turn out to be a fundamental factor in their creation. The process might reveal that at the origin of painting and sculpture there lies a mummy complex' (Bazin 2005: 9). This leads us to the relationship between art and death. Images serve the purpose of the conservation of a historical truth in that they document and immortalize the mortal. This, we may say, had also been an ambition in Sokurov's films about historical figures, where 'the political leader has been powerful but not immortal; art, by contrast, powerless in the politics that produced it, may reasonably aspire to immortality' (Condee 2009: 168).

The Marquis twice comments on the smell of oil paint and formaldehyde, referring to himself as a relic of the past, as well as to the freshness and immortality of the paintings. Similarly, the guests who arrive for the ball along with the Marquis and the Narrator at the film's beginning reappear 85 minutes – and 300 years – later for the ball, without having aged, while Catherine the Great literally withers away over thirty minutes of screen time. Some rooms contain the future (from the perspective of the oblivious Marquis), whereas others compress past artworks with contemporary visitors and the timeless ghost of the Marquis. The journey through the space of the past is a journey through time, but the two never intersect. History flows chronologically, yet it coexists simultaneously with the present (the visitors in the museum) and other epochs (that which is represented on canvas).

Sokurov's relationship to the past is not nostalgic, which suggests the painful longing (*algos*) for a place (*nostos*); his is a longing for another time, the passing of which he mourns; his is the sorrow for a lost age, or melancholia.[10] He wishes to layer time and allow the past to seep through into the present: 'In *Russian Ark*, Sokurov's constant accentuation of framed spaces highlights not only the passage of life into art's eternal realm, but also the passing of art into the living sphere' (Harte 2005: 58).

TIME: *KAIROS* VS. *CHRONOS*

In his outstanding article on *Russian Ark* (discussed in more depth in Chapter 5), Dragan Kujundzic (2003) offers a close analysis of temporal layering in the film. It is somewhat more complex than the suggestion that '*Russian Ark* serves to illustrate the paradoxical wholeness of Sokurov's cinema, torn between past and future, movement and stasis, fragment and totality' (Szaniawski 2014: 167), and worthy of thorough consideration here. Sokurov himself has said about time: 'For me, not one of those times has ever stopped or ended. Historical time cannot depart, cannot collapse' ('Press Release' 2002: 5). The film-maker is interested in '[t]ime in its entirety – the present continuous tense' (Tuchinskaia 2002). For Sokurov, then, there is no border between past and future, between one epoch and another; they all exist in the same space, maybe sealed in different compartments, but within spaces where transgression is possible.

Indeed, two different concepts of time can be applied to *Russian Ark*: time as a historical experience, unfolding in a linear, chronological movement (as in the chronology of historical events); and time as a vertical concept, as in medieval culture, where time was measured against eternity, or rather eternity's interventions. In

relation to Sokurov's oeuvre, Mikhail Iampol'skii has defined these times as *chronos* (time as flow) and *kairos* (a supreme moment in time):

> The *kairos* of the *Russian Ark* has a different configuration than in *Taurus*. This is not about falling out of history as timeless stasis, the time of the end, but about falling out of history *in motion*, as an embodiment of *uninterruptedness*, the accidentally penetrating 'happiness' of an immobile past, the firmness of cultural 'museum' forms of the past. Kairos here is the destructive force of movement through coincidence uniting epochs and creating meaning where there was merely an 'optical illusion'.
>
> (Iampol'skii 2003: 54; emphasis in the original)

Kujundzic (2003) also differentiates understandings of time as either messianic (measuring up to the apocalypse) or Hegelian (going to the end of history), thereby drawing a similar distinction to Iampol'skii's between *chronos* and *kairos*, that is the flow of time and the eternal moment. Both principles rely on the horizontal and vertical perception of time and their intersection. Indeed, Mikhail Bakhtin (1981: 157) links this vertical conception of time to Dante, who suggests that the circles of hell, purgatory and paradise were stacked one on top of another: 'The temporal logic of this vertical world consists in the sheer simultaneity of all that occurs (or "the coexistence of everything in eternity"). Everything that on earth is divided by time, here, in this verticality, coalesces into eternity, into pure simultaneous coexistence'. Bakhtin argues that only in such simultaneity can the true meaning of past, present and future be understood.

According to Kujundzic (2003), a similar view on the vertical organization of time is offered in Walter Benjamin's reading of Paul Klee's *Angelus Novus* (1920), in which the fear of a loss of control over time is linked to the theme of blindness. With his face turned to the past (rather than the present or future), the angel suggests that the future is a wasteland, similar to the grey and murky non-space in the final frames of *Russian Ark*:

> Where we perceive a chain of events, he sees one single catastrophe which keeps piling wreckage upon wreckage and hurls it in front of his feet. The angel would like to stay, awaken the dead, and make whole what has been smashed. But a storm is blowing from Paradise; it has got caught in his wings with such violence that the angel can no longer close them. This storm irresistibly propels him into the future to which his back is turned, while the pile of debris before him grows skyward. This storm is what we call progress.
>
> (Benjamin 1968: 257–58)

The unblinking eye of the camera and the flatness of the digitally recorded image facilitate an uninterrupted view, or flow, of time, much like the River Lethe, which represents forgetting (Ippolitov 2006). There is no blink of the camera, no closure of the lens, visually emphasizing the constant vigilance in the museum, but also the absence of any divisions in time that would sit on the vertical axis, as described in Bakhtin (1981).

Moreover, the unblinking eye can serve to explain the narrator's blindness at the film's beginning, and his own invisibility to the spectral characters that populate history:

> The film is therefore a take within a take, both an excess of visibility following the events, and the exposure and display of the very capacity of the film to see. The film watches the very gaze of which it is both the vigilant agent and the blind spot. This could explain, once again, the narrative opening into visibility out of the narrator's blindness.
>
> (Kujundzic 2003)

Sokurov stacks time by embedding different temporal layers in a single frame: there is the Narrator of the present time and today's visitors to the museum; there is Custine and the nineteenth-century guards and guests; there are

different periods of history and paintings of the past; there are observers who are contemporaries to the time of the action; there is the Spy who transgresses time (along with Custine); and there are Soviet sailors and soldiers. Sokurov's perception of time is open and in flux; there is no closed system:

> The unclosing eyes of the angel of history is reproduced in this movie as the unclosing monocular gaze of the one long single take which records history *in statu nascendi*. That is, at the site of its production and commemoration, its life and its ruination.

> (Kujundzic 2003)

Sokurov's interest in ruins – and specifically the ruin painter Hubert Robert – is not accidental: the ruin is a building that beholds its own collapse in the future, with the destruction and apocalypse embedded within the process of creation. In other words, it is the death of a still unborn idea. Therefore, the concept of nostalgia is not appropriate for Sokurov: it is for a place that actually existed, whereas melancholia is the mourning for something that has not been, that has not been fully realized, and that has already disappeared.

Iampol'skii (2003: 32–33) defines Sokurov as 'master of incongruence' [master nesootvetstviia] because he is able to work with two hermetically sealed worlds, where dissociated events are organized through a principle that we do not know. Sokurov gives significance to the insignificant. History lies at the intersection of two actions, one accidental and the other coinciding with a determined flow of time. Sokurov harmonizes these two temporalities, *kairos* and *chronos*. He removes characters from a concise historical time in different ways, usually involving an enclosed space that eclipses real time, thereby allowing it to seep in through still images and newspapers (as in *Taurus*), or documentary footage (as, for example, in *Molokh*): 'Sokurov strives to extract a historical personality from time and place it into a context that paralyses completely its temporal suitability' (Iampol'skii 2003: 39). Iampol'skii also suggests that *kairos* is a present without temporal dimension, which Sokurov defines as 'present continuous', and which sits in the clash between the event and the discourse, in the caesura or the space in-between – a space where the past is turned into an exhibit through theatricalization, repeating itself in different historical times. Indeed, Custine commented in his *Letters* that life at court seems like an eternal rehearsal, where the tsar is never quite content with the final performance. It is a space where paintings come to life, although their surfaces remain frozen and still. Sokurov effectively creates an optical illusion of life on a 'dead' surface.

Custine describes the city of St Petersburg as a chimera, a ghostlike place, much like the image of Akakii Akakievich that Nikolai Gogol' would paint a few years later in 'Shinel''/'The Overcoat' (1842). St Petersburg is a city without roots, designed for another climate (the loggias were designed for Italy), and unable to sustain the cold and damp winters. According to Custine, cracks have already appeared on the Alexander Column, since even granite and marble are unsuited for the Petersburg climate (Buss 1991: 70).

Sokurov revives history with a view to laying different layers of the past onto the present: 'The retrospective observation of history thus becomes a pure act of contemplation and consideration of Russian identity' (de Keghel 2008: 81). Since this stacking of different historical eras is not simply a formal experiment, the implication is one that has an impact on Russia's concept of national identity, its unique role between Europe and Asia, and its belonging to European traditions. Therefore, this takes us back to the nationalist views that Sokurov appears to hold and promote in his films.

EUROPE VS. ASIA

Using the European Marquis as a prism for viewing Russian history and culture, we are invited to acknowledge only those historical elements that are pale imitations of European culture and history, while detaching Russia's history of the twentieth century from its continuous historical chronology. The Soviet era is visually cut out

of the film, with only the devastation of the war leaving a trace, thus suggesting (as we will fully appreciate in *Francofonia*) Europe's inability to protect its own culture. In one sense, nothing of value remains of Russia at the end of the twentieth century apart from the protection of European culture, implying that Russia without its European connection is void and has no meaning. At the same time, Russia is neither part of Asia nor its master, as Sokurov stresses: 'The bent for Asia, for the Caucasus, the desire to subjugate them, is in my view a global mistake on Russia's part' (Ivanov 2002).

In ignoring, rejecting and annihilating the here and now, Sokurov adopts a rather opportunistic view of Russia as the lost child of European culture who is trying to reattach itself. Sokurov says farewell to Europe as he leaves the year 1913, thus annihilating Soviet history. The ark protected European culture not only from the devastation of the war, but also, at least in this narrative, the devastation wrought during the Soviet era. What remains in the ark is the splendid imperial past, when Russia enjoyed close connections to European culture, thereby eclipsing the horrors of the Soviet regime, and with it also the Russian art movements of the late nineteenth and early twentieth century. Having severed its links with Europe, the ship – *à la* Fellini – is destined to sail forever in the limbo between Europe and Asia, between imperial glory and both Soviet ambitions for a superpower and Putin's revival of Russia's nationhood.

While creating a masterpiece of technological mastery in a German-Russian co-production, Sokurov creates an unbridgeable abyss between Europe and Asia, placing Russia clearly in a European context, of which it is a poor imitator, a chimera, a ghost ship. The Hermitage is the ark carrying Russia's cultural heritage; as such, it harbours vast collections of Asian, oriental (its most recent directors were all orientalists) and Russian art, as well as Western European art. Sokurov chooses to ignore the oriental and Asian part of the ark's content, concentrating exclusively on the parts that deprive Russia of its own cultural identity, and that bear witness to the imported cultural heritage from Western Europe. In this sense, Sokurov seems to stand at the other end of the scale from Nikita Mikhalkov's nationalism and pride in Russia. However, the two film-makers offer a similar set of images – either filmic or painted – that betray space and merge artistic visions with historical reality, creating a national identity through the manipulation of space and time. Sokurov distracts our attention from the space by absorbing us into the time-trap of the time-track of the single shot. Yet his manipulation of painted and enacted spaces creates a much more dangerous illusion, since it smears national identity into a global history. From this position, it is a small step to develop a nationalist view that perceives Russia as a superior country because of its suffering, its readiness for sacrifice and its mission:

> For Sokurov […] the West was the place where all the most important art was once produced, but is now in decline. Russia, to the contrary, survived the dark age of communism and might, by virtue of its never-extinguished appreciation for the legacy of Western art, […] serve as the redeeming ark where European culture will remain intact, while another historical deluge, which has yet to occur, drowns the decadent old civilisation.
>
> (Szaniawski 2014: 172)

In the debate between Europe and Asia, the Hermitage stands as the ark that saves European culture. Meanwhile, the ship carrying a museum collection in *Francofonia* sinks. This suggests Europe cannot look after its own heritage and needs Russia to help. Yet even Sokurov's authoritative message to the captain of the sinking ship that artworks should never have been transported on a vessel speaks of an arrogance that may be termed as 'cultural racism' wherein Russia has a superior spiritual understanding of the importance of culture and heritage, which is better than that of any other nation (although one may doubt this view strongly when looking at Russia's current cultural politics). With this view Sokurov also implies his conviction that European culture is being diluted in various projects of cultural integration (a controversial view voiced at a press conference for *Francofonia* in Venice in September 2015). Russia may be an imitator, it may lack an identity, but it has a mission. Sokurov is preoccupied with protecting high culture

(as opposed to mass or popular culture); his is a rescue mission for European heritage, a culture to which Russia does not simply belong, but which it saves. Russia is the saviour of a culture that is disappearing, vanishing, perishing in a deluge of multiculturalism, capitalism and materialism: 'this salvaging of Western civilisation can only come, at this point, from Russia (with Europe having lost its own instinct of survival and potential for rebirth…)' (Szaniawski 2014: 172).

Likewise, the choice of the content that is depicted or framed in the film is indicative of Sokurov's view of Russia's national and cultural identity. This has been discussed at length, both as a 'creative appropriation of the Western cultural tradition' (de Keghel 2008: 91) and, due to an absence of content at home, as imitative of the West:

> The dramatic tension of the movie as it pertains to the question of identification (and the Russian national identity, for example), lies in the fact that the space of commemoration relies also on artifacts that have nothing to do with Russia, but are entirely imported from the West […].
>
> (Kujundzic 2004: 222)

In the debate between Russia and Europe, Sokurov claims '*Russian Ark* as a decidedly "native" project, one, moreover, which presents a culturally hegemonic view of Russian identity' (de Keghel 2008: 91).

Russia has seen its glory under European influence, and it is only thanks to Europe that Russia has made an impact on world culture and history. The use of Custine's comment as a non-contradicted, 'authorial' voice (as I have suggested, the author's voice of the invisible Narrator has no real authority) defines 'Russian cultural heritage' as the European collections in the Hermitage, and 'Russian history' as the years 1689 to 1913.

> Russian/Soviet Communism, therefore, comes to end the epoch of the Petrine traditions that has made it possible. At once a radical erasure (the 'end' of history) and a messianic, modernist acceleration, it has wedged a caesura in Russian history and detached itself from its formative origin. […] But at the same time, it served as the teleological fulfillment of the Petrine traditions. The reforms of Peter the Great were simultaneously strengthening Russia and generating a destructuring (perhaps destruction/deconstruction/reconstruction) of its national identity by their radical acceptance of Western cultural models. The Soviet Revolution was on one level an explicit populist dismantling of these models, but by means of the same modernist techno-phantasms that they tried to eradicate.
>
> (Kujundzic 2003)

The 'hegemonic' approach suggested in Isabel de Keghel's analysis denies a democratic and popular approach, governing the selection of art and cultural objects where only high art and high culture are included. The rest is doomed to sink.

Chapter 5
Reception

The modern filmmaker questions his country's uneasy connection to its past and to Europe today.

('Press Release' 2002)

Russian Ark attracted a lot of media attention, largely for its technical feat. The world premiere took place at the Cannes International Film Festival in 2002, where the film was included in the competition programme. During the interviews and press conferences at the festival, Sokurov declared his satisfaction with being included in the competition, but claimed that he was not expecting any awards, as he did not think the jury would be able to comprehend and appreciate the complexity of his work (Bogopol'skaia 2002), positioning himself deliberately outside the 'mainstream of art-house cinema', as it were. The festival screened the film from a 35mm print, and both Sokurov and his Russian producer, Andrei Deriabin, were dissatisfied with this technical compromise. In any screening of the film from 35mm, the 600-metre reel has to be changed during projection, thereby creating a cut. Cannes did, however, also hold one digital screening (which the pair fail to mention).

In terms of distribution, the film largely went out as a 35mm print, since only a few select venues at the time were equipped for digital screening (see Chapter 1). The film grossed $3 million in the United States and Canada, and $3.6 million internationally, bringing in a total of $6.6 million and thus more than covering its expenditure (the film had a total budget of $2.5 million). It is surprising that the film did better from its US distribution than across Europe, where the 'rest of the world' international box office figures comes to one third of its total through its Australian release (grossing $1 million). In the United Kingdom, the film was released on eight screens by Artificial Eye in April 2003, increasing to 13 screens and bringing in $269,800 over its three-week run (Minns 2003).

For a foreign-language art-house film, this result is astonishing and comes despite the fact that the film won no award at Cannes. As the following survey of press responses and scholarly debates reveals, the responses vary across the geographical divide between Russia and Europe/America. The English-language responses show a preoccupation with the technological feat, whereas the Russian press is critical of Sokurov's achievement, challenging the nationalist attitude reflected in the film and accusing Sokurov of a conservative view of history, as well as, at the extreme end, of making a kitsch film to export Russian culture abroad.

Before we turn to the press reviews, though, we must pay close attention to an incident which marks Sokurov's attitude to the western (German) collaborators and partners on the project. This event tainted the project and certainly did not contribute to a positive atmosphere, highlighting instead the divide between Russia and Europe that is exposed in the film's subject-matter. It concerns the scandal surrounding Sokurov's and Büttner's nomination for awards by the European Film Academy (EFA), the European equivalent of the Academy Awards.

THE SCANDAL: EUROPEAN FILM ACADEMY AWARDS

The European Film Academy was founded in 1988 under Ingmar Bergman and 40 other European film-makers. It awards prizes every year, alternating the location for the ceremony between Berlin and another European city. In 2002 the ceremony was held in Rome, where Pedro Almodóvar took the prize for Best Film and Best Direction for *Hable con ella/ Talking to Her*, while Paweł Edelman was named Best Cinematographer for his work on Roman Polanski's *The Pianist*.

Sokurov had been nominated as Best Director and Büttner as Best Cinematographer, but in a huff Sokurov asked the Academy to withdraw Büttner's nomination, because, he argued, he was not the sole person responsible for the cinematography of *Russian Ark* and the whole film was a collective effort. This came after a string of negative comments about the German co-producers, and the fact that Sokurov had to do the post-production work in Berlin for contractual and production reasons (Tuchinskaia 2002).

Following the European Film Academy's nomination, Sokurov addressed a series of letters to the Academy,[11] asking first for Büttner's nomination to be withdrawn and then for his film to be removed from the list of nominations. The Academy, which can nominate films without permission from producers or directors, refused to consider his request. In December 2002, at the peak of the dispute, Sokurov resigned his membership of the European Film Academy (Alaniz 2011: 166–67; Halligan 2003).

In the first letter, dated 19 November 2002, Sokurov objected to Büttner's nomination, referring to the fact that he merely operated the camera and had no artistic control over the cinematography. He insisted on the film being a collaborative effort:

Russian Ark is the fruit of the work of a large group of Russian and German filmmakers. As the author of the idea, co-author of the screenplay, director, and creator of the image design of this film, I understand very well the great significance of our production for the history and practice of professional cinema. Therefore the moral aspect of the estimation of such a film is of special importance. [...] I care a lot about the group of my collaborators and cannot accept any attempt to praise the efforts of some of them without admitting the role of the others. THE FILM SHOULD BE TAKEN AS A WHOLE – only thus the contributions to this unique project of all members of the group and each of them in person could be judged.

(cited in Alaniz 2011: 166; emphasis in the original)

In the second letter, dated 29 November 2002, which follows the Academy's refusal to withdraw the film from its nominations, Sokurov was backed in his request by his Russian producer, Andrei Deriabin (although Sokurov was nominated as director, not the film itself):

As a result of the development of new technologies, it's often impossible to see the borderline at which the technical provisions of the project end and the creative act of forming the image of the film as a whole begins. The realization of this unexpected and complex conception demonstrated that the absolute author of the images of *Russian Ark* is, of course, the director, rather than the steadicam [sic] operator. To a large extent, this relates to the complexity of the task that had been set, on one side, and, on the other, to the large number of professional errors that Tilman Büttner committed during the shoot. [...] The complexity of the task that was set, no doubt, was beyond the professional ability of the steadicam [sic] operator because, suddenly, he was confronted by the distant outer horizons of his profession.

(cited in Alaniz 2011: 166)

A number of critics (Barabash 2003) have commented on Sokurov's lack of fair play (from the point of view of the human effort involved), particularly as it concerns someone who accomplished a physical feat and carried out a

set of tasks from the director that were above human expectations, which has to do with Sokurov's perfectionism concerning camerawork, as he often holds the camera himself and would probably have liked to do so in this case. Ekaterina Barabash ties this in with Sokurov's general sense of indifference to any awards, including his decision not to present the film to the committee of the national film awards, the Golden Eagle [Zolotoi orel]. In a second letter, also dated 29 November 2002, Sokurov turns even more aggressively against the Academy, before offering his resignation on 9 December:

> Your phrasing, to be frank, we have no desire to withdraw the two nominations [...] is a magnificent specimen. And this you write to a famous director, to the auteur of the film *Russian Ark,* the auteur of more than 50 films. Did I ask whether or not you have a desire? And in general, what does someone's desire have to do with the resolution of problems like this? Only respect, only the unconditional adherence to the requests of an auteur [matter], for an auteur is the primary figure in art. Even if 100 other people stand opposed to this opinion. [...] IT IS PRECISELY IN THE ACADEMY THAT SUCH A PRINCIPLE SHOULD HOLD SWAY. IF NOT IN THE ACADEMY, THEN WHERE?
>
> (cited in Alaniz 2011: 166–167)

This dispute, which both José Alaniz (2011) and Benjamin Halligan (2003) explore further in their publications (citing a range of statements both from Sokurov and Büttner about their work on the film), reflects Sokurov's obsession with control over his film – a specific, national control. It is no accident that he says 'this is a Russian, national film' (Sokurov in Bogopol'skaia 2002). Sokurov wishes to claim not just the idea, but the whole work for Russia. This is more significant here than in his other films, because *Russian Ark* concerns the relationship between Russia and Europe, wherein Russia emerges as the saviour: 'Russia inherited the sense of an immense acceleration and Messianic futurity [...] claiming that the Second Coming of Jesus Christ has already happened and found its true and real, its literal [...] fulfillment in Russia' (Kujundzic 2003).

THE PRESS AFTER CANNES

Following the premiere at Cannes in May 2002, the film received less than average critical attention, as would be the case for a non-award-winning title. The Cannes premiere led to the publication of a piece by Mark Cousins (2002) about the cinematographic feat, calling the film 'a milestone in film history', and to reviews in professional papers from Joan Dupont in *The New York Times* (2002), Allan Hunter writing for *Screen Daily* (2002) and Deborah Young covering for *Variety* (2002).

The critics all rehearse the narrative about the film compressing Russian history and art in a single take. Dupont (2002) raves about the film's technical feat as 'an extraordinary one-shot exercise in real time that never feels strenuous'. Citing much of Sokurov's words at the press conference, she is left with little to remark of her own: 'The film is like a dream, with visitors floating through thin air; only the paintings have substance' (Dupont 2002). Young (2002) is also taken first and foremost by the technical achievement: 'The Russian-German co-prod seems destined to go down in film history as a technical tour de force'. Only Hunter (2002) remains quite unimpressed: 'Sadly, the end result is still ninety minutes of unengaging tedium followed by six minutes of real charm and elegance. It will do nothing to extend the limited audience for Sokurov's work'.

In the run-up to the film's American and British premieres (and later theatrical releases), a number of critics were allowed space in major newspapers to cover the film. Reviews were written by Stephen Holden in *The New York Times* (2002), Stuart Klawans for *The Nation* (2002) and J. Hoberman for *Film Comment* (2002) in time for the film's screening at the New York Film Festival. Furthermore, Roger Ebert (2003) wrote in time for the Chicago International Film Festival, while *The Guardian*'s Peter Bradshaw (2003) covered the film in time for its April release in the United Kingdom. These reviews

came after the EFA scandal, and they go somewhat deeper than the 'technical feat' statements of the earlier texts, whilst also drawing parallels to other films so that they can contextualize *Russian Ark*. Interestingly, both Holden and Klawans tap into the 'ghost story' terminology, obviously in an attempt to write the film into some genre tradition that might speak to a broader public. Holden (2002) suggests that '"Russian Ark" is a ghost story set in the Hermitage', while Klawans (2002) titles his review 'Haunted Hermitage'. Both continue the narrative along these lines: '"Russian Ark" is a magnificent conjuring act, an *eerie* historical *mirage* evoked in a single sweeping wave of the hand by Alexander [sic] Sokurov' (Holden 2002, my emphasis). For Klawans, the film is a '*haunted* meditation on the disasters of history, and on our precarious efforts to rescue something from the flood. The melancholy that has pervaded many of his previous films […] also seeps delicately through *Russian Ark*' (Klawans 2002, my emphasis). Klawans further identifies the melancholy element which allows him to connect the film to Sokurov's previous work. He carefully explores the cinematographer's ruse of pausing during the shoot so that the next sequence of action can be prepared before movement resumes (for instance, when the camera focuses on paintings or, on one occasion, on the Spy's hands). Ultimately, Klawans (2002) is intrigued by the single take, trying to see how it works technically and to identify its purpose: 'Maybe I can rephrase Sokurov's statement: By taking place in real time, the shot becomes like a steady searchlight cutting through darkness, while the imagined eras are like eddies that pass intermittently through the beam'.

Hoberman (2002) perceptively links the digital take with the film's story, classifying *Russian Ark* as 'anti-*October*', wherein Sokurov rejects montage in favour of a single breath of historical time. Hoberman not only explores the imagery, but also the relationship between Custine and the Narrator, and finds that the 'narrator mildly contradicts (and at times, defensively corrects) the caustic marquis's remarks on Russia's inability to grasp European culture'.

The legendary Roger Ebert (2003) wisely and wittily suggested that if there had been a cut in the film, we may have questioned the ellipsis of Soviet history or other things in the film's narrative; in other words, the technical feat serves as a distraction. He associates the lack of cuts with the trance into which the film transposes the viewer as the camera whizzes us through time: 'If cinema is sometimes dreamlike, then every edit is an awakening. "Russian Ark" spins a daydream made of centuries' (Ebert 2003). Ebert is full of praise for the film's technical feat, but he is one of the few writers to connect it consistently to its artistic idea:

> Apart from anything else, this is one of the best-sustained ideas I have ever seen on the screen. […] The film is a glorious experience to witness, not least because, knowing the technique and understanding how much depends on every moment, we almost hold our breath.
>
> (Ebert 2003)

In the British press, Peter Bradshaw (2003) found a way of inscribing Sokurov into a postmodernist narrative, reading the film as an installation: 'Sokurov has composed a cinematic love letter to the Hermitage museum in St Petersburg […]. He has done this by contriving a kind of installation-exhibit, something between cinema and theatre'. He also embeds the film into a cinematic context beyond Eisenstein's montage and the long takes of Hitchcock's *Rope* (1948), impressed by the single take sought in other films: 'Mike Figgis's *Timecode*, on video, cannot match it for length, and Hitchcock's *Rope* had to find areas of complete blackness to hide the joins' (Bradshaw 2003).

Writing for *Sight & Sound*, Geoff Macnab (2002) also starts off by praising the technical feat of the single take, but then goes deeper in his analysis of the history that the film presents. He recognizes the selection of emperors who made a contribution to the museum to be subjective: 'thanks to her [Catherine] St Petersburg became one of the most cosmopolitan cities in the world' (Macnab 2002: 20). He suggests that the historical scenes are less re-enacted and staged than figments of the imagination, tapping into the ghost story narrative: 'Everything they see is a projection of their imagination' (Macnab 2002: 20). But he also critically views the film's reactionary potential in the way Sokurov represents history:

Russian Ark could easily seem a reactionary paean to a lost empire. That it does not is attributable to the often self-mocking dialogue between the marquis (who has a love-hate relationship with Russia) and the film-maker, who is forever questioning the Slavic obsessions with suffering and the past.

(Macnab 2002: 21)

This picks up on a comment made by Andrew Horton (2002) in his review for the online magazine *Kinoeye* following the film's screening at Karlovy Vary: 'The camera [...] alternates between having gruff arguments with his obtuse an opinionated companion and passively watches him marvel at the sights he sees and the people he meets'. Horton contextualizes the film within Russian cinema and Sokurov's own oeuvre, connecting to the theme of history and death, and of a mismatch between character and time.

In his article for *Senses of Cinema*, Benjamin Halligan (2003) offers a perceptive account of the way in which Sokurov flattens the perspective and shifts the sensation from depth and volume to non-visual methods, relying on touch, movement and speech to express the relationship between art and the viewer. He also sets Sokurov apart from Bazin, who suggested that the camera could capture truth if only it could run continuously, presenting life as it is, so that ultimately cracks would appear on the surface. These cracks are what Sokurov is interested in when focusing (both here and in *Hubert Robert*) on the canvas rather than an overall view, revealing uneven and shining surfaces that are not dissimilar to the actual ruins painted by Robert, so that the skin of the painting becomes a dead surface of the living object, preserved through and under the oil paint. The friction between life and death is what makes Sokurov's work stand out from contemporary auteur cinema: 'Sokurov's reality-effect form *par excellence* is applied to anything but a recognisable reality – and this is the violation of the Bazinian maxim' (Halligan 2003). Halligan continues this argument with reference to *Krug vtoroi/The Second Circle* (1990), which deals with procedures after a death:

The corpse, in a way the central character of the film, acts like a kind of black hole – time has ceased for it, yet it still sucks in time, emptying out the rest of the film of anything but the most rudimentary ways to note the passing of time.

(Halligan 2003)

This reading of time elapsing after death (when time stands still) is useful for understanding the concept of vertical and horizontal time in *Russian Ark* as discussed in Chapter 4: death is timelessness, a state of eternity, which is rendered in the static paintings that immortalize the everyday, as well as spiritual and historical time codes.

Halligan (2003) also suggests a parallel to Dante's *Inferno* in terms of the sense of being lost on the road, at a crossroads, in a limbo between here and there, between life and death: 'It is from this perspective, the eye of the dead beheld by the eye of the living, that *Russian Ark* occurs'. It is the perspective of a nineteenth-century visitor to the Hermitage which opens for him the pages of past history and lives, a view that is captured by a modern, mobile, unblinking camera offered by *Russian Ark*. Halligan brings in a personal experience of being lost in communist Yugoslavia, citing Slavoj Žižek's suggestion that Europe needs to assert itself as the 'Second World' and thus echoing on one level Sokurov's concern with the future of Europe.

ACADEMIC DEBATES

In May 2003, Dragan Kujundzic wrote a postmodernist critique of *Russian Ark*, offering an impressive engagement with the concept of time and claiming that the film presents an erasure of traditional time. Some of his points have already been discussed in Chapter 4, so I focus here on the overall argument. His article, published in the online

journal *ArtMargins* and later republished in *Quarterly Review of Film and Video*, led to a series of responses in the format of a 'roundtable' in *ArtMargins* in July 2003.

Kujundzic offered an analysis of the film that adopted a range of approaches for its deconstruction. First, he dwelt on the film's historical side and its performative element, making room for a single and unique repetition. His interpretation of time is not dissimilar to the distinction between eternal time (*kairos*) and the flow of time (*chronos*) suggested by Mikhail Iampol'skii in relation to Sokurov's oeuvre (see Chapter 4). Kujundzic's assessment of Russia's messianic role and its spirituality explain Sokurov's drive for the preservation (or archivization) of the country's history as a mobile museum exhibit, which may be either the result of a loss of memory or an attempt to protect against it. Thus Kujundzic explains both the spectral characters (a ghost from the past, an invisible narrator-eye) and the film-maker's – and his camera's – desire not to close that eye (this is also connected to the vigilance of the state, as noted by Custine). Kujundzic draws attention to the numerous references to touch and blindness during the excursion through the museum, and links this to Walter Benjamin's reading of Paul Klee's *Angelus Novus* (discussed in Chapter 4). He links the theme of ruins (which he notes also in Hubert Robert's paintings in Sokurov's earlier film) and a preoccupation with death detected in Sokurov's films to a blurring of the line between the visible and the invisible in *Russian Ark*. Ultimately, Kujundzic suggests that the film reveals melancholia typical of Sokurov's oeuvre as a whole, looking back from a dead or dying world at life as it fades, loses colour and dissolves. Moreover, Kujundzic (2003) inscribes the scandal around the EFA nomination into the film-maker's view of the divide between Europe and Asia, suggesting that the denial of a cultural collaboration 'appears as the blind spot, and incapacity to see the ideological implications of this protest against the very genealogy of the movie. Sokurov appears as the jealous twin of his European (br)other'. Although Kujundzic's reading of the film is wide-ranging and coherent to the point where it leaves very little unsaid and unread, it stimulated a series of responses by invited critics and scholars.

These responses include a piece by Katja Petrovskaja (2003), who charges Sokurov with an overtly Slavophile view imbued with a nationalistic message, which is explicit when he denies the viewer another perspective than that of his single lens. She polemically calls the film a 'banal cartoon under hypnosis' and 'technically unique but dubious pseudo-spiritual kitsch' (Petrovskaja 2003). For Petrovskaja, the single take is a further indicator of an authorial view being imposed here: 'The absence of montage in this film is a very dangerous symptom for the growing symbiosis of "independent intellect" and the usurpation of point of view, which is slowly but surely taking place in Russia where, actually, even oppositional TV is brought to zero' (Petrovskaja 2003). She suggests an overlap between Sokurov's vision of Russian history and Putin's nascent attempts at rebuilding Russian national identity: 'And finally even with eyes wide open one could not understand what ideologically distinguishes Sokurov's *Russian Ark* from the main principles of Putin's policy' (Petrovskaja 2003). Petrovskaja (2003) concludes that the film leaves no room for individual agency and shows history as unrelated to man, while the film-maker assumes full control over his work: 'There is no concept of responsibility in this perception of history; therefore there is no concept of consciousness. There is no concept of personal-citizenship, but there is a concept of an artist-creator'. She rightly levels charges at the directorial control that Sokurov assumes, but fails to evidence this with examples from his role as Narrator – a character who lacks agency, who is led by (an)other and follows throughout the film until the final scene when their paths part.

In another contribution, Ulrich Schmid (2003) compares Custine to Nosferatu, a demonic force or vampire who sucks blood from Russia: 'Custine wears a black suit and spreads his long fingers like Murnau's Nosferatu', a reading also suggested by Benjamin Halligan (2003). As we have already explored in Chapter 4, Schmid goes further by arguing that Sokurov exorcises demonic impulses from his own soul through this figure. Schmid substantiates such a reading with reference to a scene where Custine alleges that Sokurov is the author of his book *Russia in 1839*, suggesting Custine sees the Narrator as a modern version of himself. Schmid (2003) also has an interesting take on the role played by Valerii Gergiev: 'Sokurov leaves no doubt that Gergiev is the new Noah who enacts Russian

culture anew in the 21th [sic] century', unfortunately without providing visual or narrative evidence to support this interesting hypothesis.

In his review for the roundtable, Raoul Eshelman (2003) explores the performatism that he sees in the film, arguing that a world is created for us which forces us to identify with it, so that effectively the director is God. His reading is not dissimilar to that of Petrovskaja (2003), who links the film's performatism to the film-maker's view. Eshelman then compares the use of the hand-held camera to Dogme 95, although he does not explain how the staged and choreographed history fits into the 'Vow of Chastity'. Repeating Sokurov's statement about the single take as a means for his artistic goal, he further identifies layers of time and connects them to the theme of transcendence.

Concluding the roundtable, Natasha Drubek-Meyer (2003) discusses the impact of digital technology and the death of the analogue medium, while Nele Sasz (2003) summarizes the film's production history as an anniversary or jubilee film, discussing the various hitches associated with such a venture.

Another interesting debate was launched with a much-cited article by two Harvard scholars from the Davis Center for Russian and Eurasian Studies, art historian Pamela Kachurin and historian Ernest A. Zitser, which was first published in the *NewsNet* bulletin of the American Association for the Advancement of Slavic Studies (now Association for Slavic, East European and Eurasian Studies) in 2003, before being republished in *Historically Speaking* in 2006 (with an online version, from which I cite here). Kachurin and Zitser (2006) primarily tackle the treatment and representation of history in the film, concerned as they are with Sokurov's 'troubling ideological and political messages'. They tease out from the film – as well as from Sokurov's discourse about the film – his disdain for the level of culture and education among American audiences (we should not forget that this is where the film grossed $1 million at the box office!): 'Sokurov believes that Americans audiences are simply unredeemable cultural philistines. And *Russian Ark* is his rod of chastisement' (Kachurin and Zitser 2006). Moreover, they highlight Sokurov's view of Russia as the saviour of European culture, citing a statement he made for the website of the largest independent cinema chain in the United States, Landmark Theatres:

> [T]he time has again come for people to build arks and that there must be no delay, and that the Russians have already built their Ark, but not just for themselves – they will take all with them, they will save all, because neither Rembrandt, nor El Greco, nor Stasov, nor Raphael, nor Guarenghi [sic] nor Rastrelli will allow an ark such as this to disappear or people to die. Those that will be together with them […] will definitely go to heaven.
>
> (Sokurov in Kachurin and Zitser 2006)[12]

Sokurov clearly formulates here his vision of Russia's unique role, standing as it does between Europe and Asia; but most importantly, he expresses his conviction that this *Russian* ark safeguards and preserves European culture. In fact, it has on board *only* European culture, and no Russian culture – a suggestion to which we shall return in the Conclusion in connection with *Francofonia*.

Kachurin and Zitser (2006) are eager to draw out the distinction that Sokurov suggests between 'Western "civilization" and Russian "culture"', one that stands in sharp opposition to Custine's observations about Russia: 'Custine did not hesitate to place Russia on the other side of the great cultural divide between European civilization and Asian barbarism'. Coming close to Schmid's suggestion discussed above, Kachurin and Zitser (2006) argue that '*Russian Ark* may be seen as Sokurov's attempt to exorcize Custine's ghost from the Russian national consciousness'. They also comment on the lack of agency with which the figures of history are endowed; rather, the notion of sacrifice sets Russia apart from, and at a higher level than, the 'decadent West':

> It is, rather, a visual illustration of the nationalist trope that posits a distinction between a nation willing to make the ultimate sacrifice in the name of cultural treasures and universal values (*dukhovnye tsennosti*) and a

'civilized' country that simply lets the 'Huns' take over its glittering world capital without a struggle. [...] Sokurov presents Russia as the Christ of modern nations and the only hope of salvation for a materialist, bourgeois, and decadent West.

(Kachurin and Zitser 2006)

Their perceptive, albeit provocative, reading of Sokurov's nationalist views in the representation of history was echoed in the Russian press.

RUSSIAN VIEWS

The Russian press responded to *Russian Ark* with a delay of almost a year, since the film first took to international festivals and markets before it was released in its home country. The Russian premiere took place in the Hermitage Theatre during the tercentenary celebrations for St Petersburg, on 27 May 2003.

The film then had a very limited run in one cinema in Moscow and at another in St Petersburg. Meanwhile, the Russian producer Deriabin continued to complain about the films' lack of support and the fact that the Russian Ministry of Culture and the city of St Petersburg did not help with the film's advertising or with getting a deal with local cinemas, which were all screening American blockbusters that would draw crowds. The whining tone of Deriabin's text published in the major national newspaper *Kommersant* (2003) echoes the inability of many Russian producers at the time – including those of more mainstream films – to place their films into Russian distribution, a situation that would improve slightly only after 2004. However, there is also a sense here that Sokurov considers himself as someone special who deserves special treatment, in a similar vein to the position he tried to forge for himself around the EFA nomination. Sokurov clearly sees himself as *the* Russian auteur, the one chosen to represent Russia at Cannes over and above Pavel Lungin and Andrei Konchalovskii (candidates during the selection process for 2002), and one of the most frequent visitors to the Côte d'Azur.

Thus, the eminent St Petersburg critic and writer Tat'iana Moskvina (2003) began her review of the film in *Moscow News* by querying the motivation behind Sokurov's invitation to Cannes and expressing her surprise both at the spite of Russian critics and the amazement from American reviewers: 'The mirage of Russian culture of the Petersburg era celebrates itself loudly and colourfully'. She is also adamant that the ark's content is a personal and subjective choice by Sokurov, who offers, *en passant*, a glimpse into the domestic life of the Russian emperors, just as he had previously done for Lenin and Hitler, thus aligning the film with Sokurov's previous works. Moskvina also makes a perceptive comment on the camerawork:

In the ideal, the author and the camera should coincide, should be a single entity; but this was completely impossible and therefore the film has two bewildered Europeans: the character [Custine] and the cameraman, Büttner, and this in some places shifted the image towards a beautifully made playful excursion, rather than the preconceived mystery play of the auteur. And this facilitated hugely the perception of the film across the world.

(Moskvina 2003)

Moskvina suggests that Büttner's 'camera eye' must, by definition, reflect the surprised and distanced European viewer, and that it is precisely this coincidence with Custine's rather than the Narrator's perception that makes the film palatable for western audiences (in Sokurov's vein, a non-European eye would probably see everything in grey and brown filters, and indeed filters is what he predominantly applied in post-production). This vision is strange for the Russian spectator, who therefore often accuses the film of being a kitschy vision or tourist version of an advert for the Hermitage, as Komm (2003) suggested when he called it 'a richly costumed excursion of 90 minutes through the Hermitage'. Ol'ga Shervud (2002), another St Petersburg critic, who also worked on the PR for the film,

contributed a review to the Russian edition of the film magazine *Premiere,* highlighting the technical feat that allowed the director's compression and extension of time without the usual editing, but playing out history in real time. With her expert knowledge, she was able to provide detailed technical information for the Russian reader.

Dmitrii Komm wrote two reviews, one in the newspaper *Konservator* and one for the magazine *Neprikosnovennyi zapas,* the latter being an expanded version of the first. Komm is an outspoken critic of the film. He ponders the reasons for its success at Cannes and dislikes the kitsch, which for him lies in the 'slavish following of popular clichés and stereotypes, a fear of innovation and some conservative vulgarity' (Komm 2003). In the longer text, Komm compares the film's kitsch to *Sister Wendy's Grand Tour* (1994) and *Sister Wendy's Story of Painting* (1996), popular television programmes about art collections which the art historian and nun Wendy Beckett presented for the BBC. In both versions of the texts, Komm develops an argument about internal colonization, and argues that the approach of 'elevat[ing] your own whilst belittling something else' would be penalized with a fine in the advertising business. In conclusion, Komm perceptively formulates Sokurov's view of Russian society:

> The problem is not that the intelligentsia betrayed the people, but that it is too loyal to authority. It fears nothing more than floating freely and thinking independently. Thus it is not surprising that the world seems like an impetuous enemy force. Only their vessel is not an ark. Not even a Titanic. It's a Ship of Fools.
>
> (Komm 2003)

Mikhail Brashinskii, reviewing the film for *Afisha* magazine, was even more concise and much more pointed when comparing Sokurov to a Messiah who positions himself outside of, or rather above, critical discourse altogether: Sokurov, 'the poor student and hermit' and Sokurov the 'oversensitive' film-maker, merge into a third image, namely that of 'Sokurov the Messiah who brings us the Word, teaching us only about the main thing and therefore unsubjectible to the critical apparatus' (Brashinskii 2003).

An anonymous review in the liberal paper *Novaia gazeta* (2003) engaged with the organization of time, distinguishing the vertical axis of history from the horizontal of art. The reviewer detects a pairing of sorts in the choice of emperors and other characters, and stresses the subjectivity of vision, concluding with the statement that Sokurov's films are 'always a provocation' (Anon 2003). Writing on the occasion of the film's screening on the First Channel television in June 2003, film historian Dmitrii Salynskii – who is also the author of a monograph on Andrei Tarkovsky (2009) – commented on the technical feat and the slow release of the film in Russia. He suggests a restorative view of the past that emphasizes the film's voyeurism into the private lives of rulers, without any political implications.

Sergei Kudriavtsev, a film critic with a wide international scope, sees absolutely no difference between *Russian Ark*'s single take and an edited film with cuts, and suggests that this is a missed opportunity. He echoes the concern of his colleagues that the film represents an export version of Russian culture, and not even a good one:

> [Y]ou feel during the screening an excruciating sense of shame, for the provincial complex-ridden Russia, which as best as it can tries to present itself as a cultured European nation, but suffices it to look at the faces in the frame, and listen to the conversations of those dressed up and made up people who pretend to be aristocracy, quite in the tradition of some rural amateur performance.
>
> (Kudriavtsev 2003)

Ekaterina Barabash (2003) of the independent paper *Nezavisimaia gazeta* explores the context of the production and the scandals around EFA, as well as the delay in the film's domestic release and the lack of a screening for the national awards. She deplores Sokurov's conduct and wonders what this film actually achieves.

The former president of the International Federation of Film Critics (FIPRESCI) Andrei Plakhov – probably the best-known Russian film critic with an international reputation – wrote a brief review of the Cannes screening for the paper *Kommersant*. He reported on the divided reception at the festival, politely commenting on the 'riddle of the Russian soul seen though an intimate gaze at culture'. He deems the film a project of Russian Hollywood that 'points at the potential for a Russian epic' (Plakhov 2002), and his evasive vocabulary speaks volumes here, with the term 'potential' suggesting it does not achieve this status: it is a riddle, but not a statement.

Russian press coverage was rather thin, probably due to the initial coverage going out with the film's release in Cannes and then the year-long wait before it was shown in Russia. This meant a repeat review would be unlikely in those editions that had already covered the Cannes screening. Such festival reports are usually rather short, because journalists often have to cover two or three competition films per day, and they need to cater for a wider audience who will generally want to know about the stars and the blockbusters.

Only a few Russian critics and film historians have since written about the film, including Mikhail Iampol'skii in *Kinovedcheskie zapiski* (2003), which also published an article by the Hungarian critic Ákos Szilágyi, and a review by the film historian and eminent film-maker Oleg Kovalov in *Iskusstvo kino* (2003). Kovalov analyses the spectral characters and the flatness of the image, agreeing with those critics who see the use of the new technology as not contributing to the overall effect. He also comments on the inadequate reaction of the museum visitors to the paintings, and defines Sokurov's attempt as a 'conceptualist project' that must be placed into a cultural context – something that critics have avoided. He refers to Eisenstein's *Battleship Potemkin*, seeing an echo of the ark in the battleship itself, as well as the Odessa steps sequence as a parallel to the final descent in *Russian Ark*. Kovalov also relates the film to broader cultural events, including other foreigners in Soviet cinema; the deluge and the 'Bronze Horseman' that define the relationship between people and power; and the ark with the peasants and workers from the new world in Vladimir Mayakovsky's play *Misteriia Buff*/*Mystery Bouffe*, staged in 1918 on Palace Square to mark the anniversary of the Revolution. Kovalov (2003) also identifies the restorative longing for an imperial past that underlies the narrative: '[the ark] floats slowly from an era of revolutionary shake-ups to an era of conservative restoration'.

Overall, the coverage in both Russia and from abroad, and either from the press and scholars or film historians, reveals some common denominators: an appraisal of the technical feat, although its purpose was not always convincing; the amazement or bewilderment at the historical range and coverage of paintings; and a concern about Sokurov's view of Russia's cultural hegemony. It is the last of these issues that deserves some further clarification, which is best done in the context of Sokurov's *Francofonia*.

Conclusion: The sinking ship

If the vessel of the Hermitage is indeed loaded both with Russia's history and one of the largest collections of European art in the world, sealed hermetically and set to sail 'forever', we may wonder about its destination. It appears that this ark, loaded with treasures of European culture, will never dock, but float eternally in a grey and murky non-space, a wasteland of history lying outside the impressive buildings of the Hermitage which, after the end of the historical timeline covered in *Russian Ark*, would be looted and devastated by agents of history – whether the Bolsheviks or the Nazis appears to make little difference for Sokurov. What matters for him is that Russia has saved European culture over centuries, often at the cost of human lives. This sacrifice includes the million people who perished during the Leningrad Siege, but considered a price worth paying for the ship's precious cargo, if we follow the debate that Custine and the Narrator have outside the Hermitage's room with the empty frames. *Francofonia* reiterates this claim when it contends that 'the Hermitage, Russia's answer to the Louvre, was spared the Nazi scourge at the cost of no less than one million victims' (Anon 2015).

After finishing *Russian Ark*, Sokurov did not immediately return to the theme of museums and art. Instead, he busied himself with the completion of his family dilogy (*Father and Son*, 2005), his tetralogy of leaders (*The Sun*, 2005; and *Faust*, 2011), and returning to the geopolitical issues of a broken empire in *Alexandra* (2007). Finally, after thirteen years, he released another museum film – *Francofonia* – touted for the Cannes Film Festival as a French-German-Dutch co-production, but rejected by the selection committee. It premiered at the Venice International Film Festival in September 2015.

Francofonia is another excursion into museum spaces. This time, Sokurov takes us not on a journey through time and history in a single breath but, on the contrary, whirls us around: between the history of art objects and their conquest under Napoleon, the Louvre during the Occupation of 1940–42, World War II and the present; between Paris, St Petersburg and a vessel sailing in a stormy ocean; and between still photographs and newsreel footage, fiction film images, and fragmented and pixelating Skype footage from a ship on a computer screen. The continuity of *Russian Ark* is deliberately ruptured on all levels, including the visual, as an optical soundtrack runs along part of the historical footage and old photographs are shaded in sepia tones. Both Tolstoy and Chekhov appear in the film, in moving and still images: they can no longer comment, although both held strong views on art. As if this was not enough, Sokurov brings to life the character of Marianne, touting her Revolutionary slogans of 'freedom, equality and fraternity' [*liberté, égalité, fraternité*] as she roams through the rooms of the Louvre alongside Napoleon Bonaparte.

While telling the story of the protection of artworks contained in the Louvre during the Occupation, two individuals are singled out as the saviours of the European cultural heritage (as opposed to the collective effort made by the Russian people). It is thanks to the loyalty and devotion of two men – Count Franz Wolff-Metternich (who was in charge of culture in France during the German Occupation) and Jacques Jaujard (the director of France's national museums, including the Louvre) – that the collection of the Louvre remained intact and inside France.

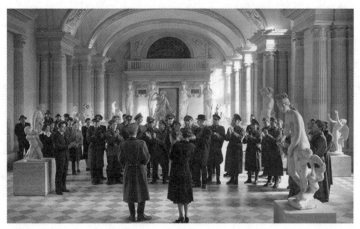

Figure 25: The Louvre in *Francofonia*.

Jaujard transported the paintings out of the capital to Sourches, among them the oversize canvas (at five by seven metres) of Théodore Géricault's *The Raft of the Medusa* (1818), tellingly depicting the wreck of a stranded ship, which was shown to Wolff-Metternich during an inspection. Tasked with operation 'Kunstschatz', aimed at preserving the cultural heritage from the destruction of the war by transporting it to Germany, Metternich made no such effort to do so, despite Hitler's orders. He thus saved France's cultural heritage from certain destruction or appropriation.

In the contemporary world, the ark of the past has turned into a real vessel that transports a precious cargo: and it could be that Sokurov is saying that this is what museums are: container ships with vast amounts of vulnerable freight' (Bradshaw 2015). Sokurov is in communication with the ship's Captain Dirk as he is about to lose his cargo in a storm: saving European art in the present day is doomed to failure. Art is part of global transportation networks, subject to digital communication processes, but nothing special. Sokurov, who was able to capture the content of the ark in his native St Petersburg, cannot do anything to rescue the collection from the drowning ship. This is Europe's cargo in times quite unlike World War II, when people risked their lives and careers to protect art (Wolff-Metternich was recalled to Germany in 1942 due to his refusal to 'repatriate' the artworks). In the past, art was often a reason for warfare and conquest, stripping other cultures of their heritage and roots, uprooting them and depriving them of an identity. For Sokurov, these roots were European in *Russian Ark*, when Russia assisted Europe in preserving its culture whilst simultaneously assimilating its 'common' heritage with Europe. In *Francofonia*, there is no cultural differentiation between Russia, Germany or France in terms of belonging: the Hermitage during the Siege, German museums during the Blitz and the empty Louvre all require protection, yet Europe alone cannot save its cargo. Isolated in a storm, and strangely without any other link than to a Russian film-maker at home in his study, the ship sinks.

Sokurov suggests, then, that Europe should stay out of Russia's missionary path. The Russian ark remains safely docked in St Petersburg, where Russia harbours and preserves Europe's heritage: Europe itself is but a pale reflection of its past – nothing as extravagant, colourful and lively as the historical scenes of the Winter Palace. Europe's past consists of black-and-white fiction films and newsreels; sepia-tinted still photos; the dimly lit, lonely and ghostly figures of Napoleon and Marianne; the pale characters of Wolff-Metternich and Jaujard – all spectral characters from different times. Yet the past and the present do not intersect: time is out of joint, the ship sinks, and with it old Europe. Sokurov's prediction for the future of European culture could not be darker.

References and select bibliography

ON CUSTINE

Buss, Robin (ed.) (1991), *Marquis de Custine: Letters from Russia*, with an Introduction (pp. vii-xxii), London: Penguin.

Dianina, Katia (2004), 'Art and authority: The Hermitage of Catherine the Great', *The Russian Review*, 63: 4, pp. 630–54.

Kennan, George F. (1972), *The Marquis de Custine and his 'Russia in 1839'*, London: Hutchinson & Co.

Kohler, Phyllis P. (ed.) (1980), *Journey for Our Time: The Journals of the Marquis de Custine*, London: Prior.

Muhlstein, Anka (ed.) (2002), *Astolphe de Custine: Letters from Russia*, New York: New York Review Books.

INTERVIEWS

Menashe, Louis (2003), 'Filming Sokurov's "Russian Ark": An interview with Tilman Büttner', *Cineaste*, 28: 3, pp. 21–23.

Sedofsky, Lauren (2001), 'Plane songs: Lauren Sedofsky talks with Alexander Sokurov', *ArtForum*, 40: 3, p. 124, http://www.thefreelibrary.com/Plane+songs%3a+Lauren+Sedofsky+talks+with+Alexander+Sokurov.-a081258061. Accessed 29 April 2016.

Szaniawski, Jeremi (2006), 'An interview with Aleksandr Sokurov', *Critical Inquiry*, 33: 1, pp. 13–27.

IN ENGLISH

Alaniz, José (2008), '"Nature", illusion and excess in Sokurov's *Mother and Son*', *Studies in Russian & Soviet Cinema*, 2: 2, pp. 183–204.

––––– (2011), 'Crowd control: Anxiety of effluence in Sokurov's *Russian Ark*', in Birgit Beumers and Nancy Condee (eds), *The Cinema of Alexander Sokurov*, London: I.B. Tauris, pp. 155–75.

Anon (2015), '"Francofonia": Review', *Screen Daily*, 4 September, http://www.screendaily.com/reviews/francofonia-review/5092521.article. Accessed 29 April 2016.

Bakhtin, Mikhail (1981), *The Dialogic Imagination* (ed. Michael Holquist), Austin: University of Texas Press.

Bazin, André (2005), *What is Cinema?*, vol. 1, Berkeley, Los Angeles and London: University of California Press.

Benjamin, Walter (1968), *Illuminations*, New York: Schocken Books.

Beumers, Birgit (2003), '"And the ship sails on…": Sokurov's ghostly ark of Russia's past', *Rossica*, 9, pp. 56–59.

Beumers, Birgit and Condee, Nancy (eds) (2011), *The Cinema of Alexander Sokurov*, London: I.B. Tauris.

Bikker, Jonathan (2005), *Willem Drost (1633–1659): A Rembrandt Pupil in Amsterdam and Venice*, New Haven and London: Yale University Press.

Bradshaw, Peter (2003), 'Breathtaking history of Russia', *The Guardian*, 10 April, http://www.theguardian.com/guardianweekly/story/0,12674,932918,00.html. Accessed 6 May 2016.

––––– (2015), 'Francofonia review – eerie look at the Louvre's vulnerable freight', *The Guardian*, 4 September, http://www.theguardian.com/film/2015/sep/04/francofonia-review-venice-film-festival. Accessed 29 April 2016.

Christie, Ian (2007), '*Russkii kovcheg/Russian Ark*', in Birgit Beumers (ed.), *24 Frames: The Cinema of Russia and the Former Soviet Union*, London: Wallflower Press, pp. 242–51.

————— (2012), 'A disturbing presence? Scenes from the history of film in the museum', in Angela Dalle Vacche (ed.), *Film, Art, New Media: Museum Without Walls?*, Basingstoke: Palgrave Macmillan, pp. 241–55.

Condee, Nancy (2009), *The Imperial Trace: Recent Russian Cinema*, New York: Oxford University Press.

Cousins, Mark (2002), 'Widescreen: The single-shot movie', *Prospect*, 20 July, http://www.prospectmagazine.co.uk/arts-and-books/5324-widescreen. Accessed 7 May 2016.

Drubek-Meyer, Natascha (2003), 'An ark for a pair of media: Sokurov's *Russian Ark*', *ArtMargins*, 5 May, http://www.artmargins.com/index.php/ilya-a-emilia-kabakov?id=273:an-ark-for-a-pair-of-media-sokurovs-russian-ark. Accessed 7 May 2016.

Dupont, Joan (2002), 'A Russian director films the flow of time', *The New York Times*, 25 May, http://www.nytimes.com/2002/05/25/style/25iht-million_ed3_.html. Accessed 7 May 2016.

Ebert, Roger (2003), 'Russian Ark', *Chicago Sun Times*, 31 January, http://rogerebert.suntimes.com/apps/pbcs.dll/article?AID=/20030131/REVIEWS/301310304/1023. Accessed 28 April 2016.

Eshelman, Raoul (2003), 'Sokurov's "Russian Ark" and the end of postmodernism', *ArtMargins*, 30 July, http://www.artmargins.com/index.php/film-a-screen-media-sp-629836893/268-sokurovs-russian-ark-and-the-end-of-postmodernism. Accessed 7 May 2016.

Gillespie, David and Smirnova, Elena (2004), 'Alexander Sokurov and the Russian soul', *Studies in European Cinema*, 1: 1, pp. 57–65.

Halligan, Benjamin (2003), 'The remaining second world: Sokurov and "Russian Ark"', *Senses of Cinema*, February, http://sensesofcinema.com/2003/film-in-the-eye-of-history/russian_ark/. Accessed 7 May 2016.

Harte, Tim (2005), 'A visit to the museum: Aleksandr Sokurov's "Russian Ark" and the framing of the eternal', *Slavic Review*, 64: 1, pp. 43–58.

Hashamova, Yana (2006), 'Two visions of a usable past in (op)position to the West: Mikhalkov's *The Barber of Siberia* and Sokurov's *Russian Ark*', *The Russian Review*, 65: 2, pp. 250–66.

Hoberman, J. (2002), 'Russian Ark: And the ship sails on', *Film Comment*, 38: 5, p. 54.

Holden, Stephen (2002), 'All of Russian history, in one glittery, unbroken take', *The New York Times*, 28 September, http://www.nytimes.com/movie/review?res=9405E2DE1638F93BA1575AC0A9649C8B63. Accessed 7 May 2016.

Horton, Andrew (2002), 'Elegy to history', *Kinoeye*, 2: 13, http://www.kinoeye.org/02/13/horton13_part1.php. Accessed 7 May 2016.

Hunter, Allan (2002), 'Russian Ark (Russkiy Kovcheg)', *Screen Daily*, 2 June, http://www.screendaily.com/reviews/europe/features/russian-ark-russkiy-kovcheg/409484.article. Accessed 7 May 2016.

Iampolski, Mikhail (1999), 'Representation – mimicry – death: The latest films of Alexander Sokurov', in Birgit Beumers (ed.), *Russia on Reels: The Russian Idea in Post-Soviet Cinema*, London: I.B. Tauris, pp. 127–43.

Jameson, Fredric (2006), 'History and elegy in Sokurov', *Critical Inquiry*, 33: 1, pp. 1–12.

Kachurin, Pamela and Zitser, Ernest A. (2003), 'After the deluge: "Russian Ark" and the abuses of history', *NewsNet* (News of the American Association for the Advancement of Slavic Studies), 43: 4, pp. 17–22. Reprinted (2006) in *Historically Speaking: The Bulletin of the Historical Society*, 7: 6, pp. 25–27, http://www.bu.edu/historic/hs/julyaugust06.html#kachurin_zitser. Accessed 27 April 2016.

de Keghel, Isabelle (2008), 'Sokurov's "Russian Ark": Reflections on the Russia/Europe theme', in Stephen Hutchings (ed.), *Russia and Its Other(s) on Film*, Basingstoke and New York: Palgrave Macmillan, pp. 77–94.

Klawans, Stuart (2002), 'Haunted Hermitage', *The Nation*, 25 September, http://www.thenation.com/article/haunted-hermitage/. Accessed 6 May 2016.

Kujundzic, Dragan (2003), 'After "after": The "Arkive" fever of Alexander Sokurov', *ArtMargins*, 6 May, http://www.artmargins.com/index.php/ilya-a-emilia-kabakov?id272: after-qafterq-the-qarkiveq-fever-of-alexander-sokurov. Accessed 7 May 2016. Reprinted (2004) as 'After "after": The *Ark*ive fever of Alexander Sokurov', *Quarterly Review of Film and Video*, 21: 3, pp. 219–39.

Macnab, Geoffrey (2002), 'Palace in wonderland', *Sight & Sound*, 8, pp. 20–22.

Minns, Adam (2003), 'Russian Ark to get digital screenings in the UK', *Screen Daily*, 23 April.

Petrovskaja, Katja (2003), 'And he saw: It was good', *ArtMargins*, 30 July, http://www.artmargins.com/index.php/ilya-a-emilia-kabakov?id=267:qand-he-saw-it-was-goodq. Accessed 6 May 2016.

Pipolo, Tony (2002), 'Whispering images', *Film Comment*, 38: 5, pp. 52, 57, 59 and 61.

'Press Release' (2002), *Artificial Eye*, 1 November.

Ravetto-Biagioli, Kriss (2005), 'Floating on the borders of Europe: Sokurov's *Russian Ark*', *Film Quarterly*, 59: 1, pp. 18–26.

Sasz, Nele (2003), 'Sokurov's jubilee film', *ArtMargins*, 21 July, http://www.artmargins.com/index.php/film-a-screen-media-sp-629836893/269-sokurovs-jubilee-film. Accessed 6 May 2016.

Schmid, Ulrich (2003), 'The empire strikes back: Sokurov takes revenge on de Custine', *ArtMargins*, 30 July, http://www.artmargins.com/index.php/ilya-a-emilia-kabaakov?id=270:the-empire-strikes-back-sokurov-takes-revenge-on-de-custine. Accessed 6 May 2016.

Szaniawski, Jeremy (2014), *The Cinema of Alexander Sokurov: Figures of Paradox*, London and New York: Wallflower Press.

Young, Deborah (2002), 'Review: "Russian Ark"', *Variety*, 21 May, http://variety.com/2002/film/markets-festivals/russian-ark-1200549455/. Accessed 7 May 2016.

IN RUSSIAN

Anon (2003), 'Krest Sokurova: vertikal' istorii i gorizontal' iskusstva' [Sokurov's cross: The vertical of history and the horizontal of art], *Novaia gazeta*, 12 May, http://www.novayagazeta.ru/society/20405.html. Accessed 7 May 2016.

Arkus, Liubov' (ed.) (1994), *Sokurov*, St. Petersburg: Seans.

----- (ed.) (2006), *Sokurov. Chasti rechi. Kniga 2*, St. Petersburg: Seans.

Barabash, Ekaterina (2003), 'Missiia Sokurova' [Sokurov's mission], *Nezavisimaia gazeta*, 22 April.

Bashmakova, Mariia (n.d.), 'Pal'chiki vse vidiat' [Fingers see everything], *Nevskoe vremia*, http://www.nvspb.ru/stories/palchiki-vse-vidyat-53364. Accessed 7 May 2016.

Bogopol'skaia, Ekaterina (2002), 'Russkii kovcheg mezhdu proshlym i budushchim' [The Russian ark between the past and the future], *Russkaia mysl'* (Paris), 6 June.

Brashinskii, Mikhail (2003), 'Russkii kovcheg' [Russian ark], *Afisha*, 15 April, http://www.afisha.ru/movie/171260/review/147590/. Accessed 6 May 2016.

Deriabin, Andrei (2003), 'Andrei Deriabin, prodiuser "Russkogo kovchega": my ne dolzhny sdavat'sia pered kommercheskimi kinoteatrami' [Andrei Deriabin, producer of Russian Ark: We must not surrender to commercial cinemas], *Kommersant*, 21 April.

Grashchenkova, Irina (ed.) (1997), 'Aleksandr Sokurov. Tvorcheskii alfavit' [Aleksandr Sokurov: Creative alphabet], *Kinograf*, 3, pp. 72–94.

Iampol'skii, Mikhail (2003), 'Kinematograf nesootvetstviia. Kairos i istoriia u Sokurova' [A cinema of incongruence: Kairos and history in Sokurov], *Kinovedcheskie zapiski*, 63, pp. 28–58.

Il'chenko, Sergei (2003), 'My Evropu liubim i ponimaem bol'she, chem Evropa liubit i ponimaet nas' [We like and know Europe better than she likes and understands us], Interview with Aleksandr Sokurov, *Gazeta*, 14 April.

Ippolitov, Arkadii (2006), "Mir – Rossiia – Peterburg – Ermitazh' [World, Russia, Petersburg, Hermitage], in Liubov' Arkus (ed.), *Sokurov. Chasti rechi*, St. Petersburg: Seans, pp. 282–91.

Ivanov, Anton (2002), 'Nash chelovek v Kanne' [Our man in Cannes], *Itogi*, 17: 307, http://www.itogi.ru/archive/2002/17/96445.html. Accessed 20 July 2010.

Komm, Dmitrii (2003), 'Kovcheg durakov' [The ship of fools], *Konservator*, 16–22 May. Reprinted in an expanded version as 'Kovcheg bez potopa' [An ark without a deluge] in *Neprikosnovennyi zapas*, 3: 29, http://magazines.russ.ru/nz/2003/29/komm.html. Accessed 28 April 2016.

Kovalov, Oleg (2003), 'Russkii kontekst. "Russkii kovcheg", rezhisser Aleksandr Sokurov' [Russian context: Russian Ark, directed by Aleksandr Sokurov], *Iskusstvo kino*, 7, http://kinoart.ru/archive/2003/07/n7-article3. Accessed 6 May 2016.

Kudriavtsev, Sergei (2003), 'A korol'-to golyi!' [But the king is naked!], *Ekran i stsena*, 21.

Moskvina, Tat'iana (2003), '…I plyt' nam vechno' […and we sail forever], *Moskovskie novosti*, 15–21 April.

Plakhov, Andrei (2002), 'Zagadka russkogo kadra' [The riddle of the Russian frame], *Kommersant*, 23 May.

'Proekt' (2002). [Material on the production of *Russian Ark*], *Kinoprotsess*, 1, pp. 107–21.

Salynskii, Dmitrii (2009), *Kinogermenevtika Tarkovskogo*, Moscow: Prodiuserskii tsentr Kvadriga.

Shervud, Ol'ga (2002), 'To, chego ne mozhet byt'' [What cannot be], *Premiere* 44 (Russian edition).

Sirivlia, Natal'ia (2002), 'Svetlana Proskurina: glazami ochevidtsa' [Svetlana Proskurina: Through the eyes of a witness], *Iskusstvo kino,* 7, http://kinoart.ru/archive/2002/07/n7-article3. Accessed 28 April 2016.

Tuchinskaia, Aleksandra (2002), 'Interview with Alexander Sokurov', *Ostrov Sokurova/Sokurov's Island,* http://www.sokurov.spb.ru/isle_ru/feature_films.html?num=39. Accessed 6 May 2016.

----- (ed.) (n.d.), *The Island of Sokurov*: Official Website, http://sokurov.spb.ru/isle_en/isle_mnp.html. Accessed 7 May 2016.

Notes

1. There is mention in some publications of 4000 actors. This was Sokurov's original plan, which had to be significantly reduced due to financial limitations on production costs.

2. At the end of 2000, eleven cinemas in Western Europe were digital; the technology was rolled out from 2005 onwards.

3. For a filmography, see Beumers and Condee (2011: 250–52); for a discussion of the documentaries, see Jeremy Hicks in Beumers and Condee (2011: 13–27); and, for portraits, see Eva Binder in Beumers and Condee (2011: 28–42).

4. I am grateful to Colin Cruise for identifying this little-known sculpture for me, which I had mistaken for Pietro Tenerani's *Psyche in a Faint* (Beumers 2011), although her raised arms did not fit that sculpture. I presume the choice of this artwork (rather than Tenerani, or indeed the Canova sculpture of *Psyche and Cupid*) may have to do with the fact that it is the only art object that two actors physically touch during the shoot, which goes against the rules and regulations of the Hermitage (which, according to Mikhail Piotrovskii in the DVD's interview, the crew had to observe).

5. The painting is also known by the title *The Prophetess Anna Instructing a Child*, and allegedly draws on Luke (2: 36–40), wherein the old widow and prophetess Anna told Joseph and Mary about the birth of a child (Bikker 2005: 60–61).

6. The Decembrist Uprising has been portrayed in films such as Aleksandr Ivanovskii, *Dekabristy/The Decembrists*, 1926; and prominently in Vladimir Motyl''s *Zvezda plenitel'nogo schast'ia/The Star of Fascinating Happiness*, 1975. The murder of Paul I features in an episode of Sergei Solov'ev's *ASSA* (1987) and is the main theme of Vitalii Mel'nikov's *Bednyi,bednyi Pavel/Poor, Poor Pavel* (2003).

7. See the comment for the costume collection at V&A http://www.vam.ac.uk/content/articles/m/mens-court-dress-russia-1720s-1917/. Accessed 28 April 2016.

8. Sketches of the 1913 ball by Dmitrii Kardovskii were displayed in a 2013 exhibition at the Hermitage. See http://www.hermitagemuseum.org/wps/portal/hermitage/what-s-on/temp_exh/1999_2013/hm4_1_337/?lng=en Accessed 28 April 2016. See also *Kostyumirovannii bal v Zimnem Dvortse*, (two volumes), Moscow: Russkii antikvariat, no date.

9. Wagner launched a vitriolic attack against Meyerbeer after the latter's death for the wealth he had accumulated.

10. Kujundzic (2003) offers an interesting reading of melancholia, which literally means 'black bile'. Fish bile was used to cure Tobit's blindness, as told in the Apocrypha.

11. These letters were published on Sokurov's website: Alexander Sokurov, 'To the European Film Awards 2002', 19 November 2002; Alexander Sokurov and Andrei Deriabin, 'Refusal to take part in the ceremony for the awarding of prizes by the EFA in December, 2002', 29 November 2002 (links no longer active, May 2016). Two letters, one asking for the film's withdrawal and Sokurov's resignation, remain partially available on the site: Alexander Sokurov, 'Letter from A.N. Sokurov of November 29, 2002', *Sokurov's Island,* 29 November 2002, http://www.sokurov.spb.ru/promo/russian_ark/ru/ark_fin2.html (accessed 6 May 2016); and Alexander Sokurov, 'Letter from A. N. Sokurov of December 9, 2002', http://www.sokurov.spb.ru/promo/russian_ark/ru/ark_fin4.html (accessed 6 May 2016). They have been cited in Alaniz 2011: 166–67 and Halligan 2003.

12. The original link to this statement is no longer active.